CREATIVE LIGHTING TECHNIQUES

for Studio Photographers

SECOND EDITION

Dave Montizambert

AMHERST MEDIA, INC. ■ BUFFALO, NY

Author's Acknowledgments

These pages are a record of my exploration formulated from ongoing research into the foundation of "Creating With Light." This foundation was pioneered by world renowned photographic educator Dean Collins.

I'd like to thank: Dean Collins for his ongoing support and wisdom, Bev for her transcribing and proofing, Mark for his collaboration, Alex Vasquez for staying up all night scanning the images, and Sylvianne for all the punctuation lessons #$@!OOO's.

Published by:
Amherst Media, Inc.
P.O. Box 586
Buffalo, N.Y. 14226
Fax: 716-874-4508

Publisher: Craig Alesse
Senior Editor/Production Manager: Michelle Perkins
Assistant Editor: Barbara A. Lynch-Johnt

ISBN: 1-58428-093-X
Library of Congress Card Catalog Number: 2002113006

Printed in the United States of America.
10 9 8 7 6 5 4 3 2 1

Table of Contents

THE FOLLOWING PAGES ARE CHALKED FULL OF incredible lighting information. You will learn how to use light to tell a story, to create impact, and to create what your mind's eye envisions without technical impediment.

Lighting theory is important. If you learn the theory you can apply this knowledge to problem-solve any situation. If you merely learn the technique, you can only apply that method to that situation or similar situations.

Unfortunately most lighting education is based solely on methodology. Unlike others, this book is designed to strike a balance between theory and methodology, teaching you universal principles and backing them up with practical applications.

Whether you photograph people, large set, tabletop, interiors, or architecture, one thing is universal: lighting. This book is about creating and controlling light quality. Its purpose is to give you the knowledge to light anything and everything from people to cars, from jewelry to silverware. It is not about methods of lighting for a single type of photography, but rather the knowledge that will allow you to light more creatively for your specialty (and everyone else's!).

Whether you photograph people, large set,

tabletop, interiors, or architecture,

one thing is universal: lighting.

Many of the fundamentals of lighting contained in this book were taught to me by the world's foremost authority on lighting, photographer/photo-educator Dean Collins. Each of these fundamentals is explained and demonstrated using images from actual photo assignments that my partner/brother Mark and I performed for real clients. Within these lessons, much space is also dedicated to all pertinent lighting techniques,

plus money saving tips and tricks that make the image work. This information will make you a "high performance" problem solver, plus help you to learn photography at an incredible rate. Every magazine, billboard, bus-board image, will become your teacher as you easily break down how images are created and implement the technique into your own repertoire. It will take you beyond merely recording light into creating with light, making you a picture-*maker* rather than a picture-*taker*.

"Tips" Boxes

Throughout this book you will find "tips" boxes like this one. These boxes contain extra technical details, creative ideas for taking the technique discussed in that section to the next level, as well as helpful definitions and reference materials. Look for these categories::

 Tech Tips—These boxes feature additional technical information to help you apply the techniques discussed like a pro.

 Quick Reminder—The information in these boxes recalls important terms and concepts that have been introduced in previous sections or that are essential for understanding the discussion.

 Did You Know?—These boxes feature extra information that may be helpful when putting these techniques into practice.

 Data for Frames . . . —Covers all the technical specifications of the images, including exposure information, camera, lens and film usage.

Fundamental Concepts

■ CONTRAST

As you are about to turn to the next page in this book, your fingers run across the smooth surface of this page. Without even looking you soon feel a change (the comparative roughness of the page ends), which signals you to pull the edge over. If you are in a relatively quiet room right now, you probably are not consciously aware of any sound, but if you take pages of this book and flip through them in quick succession, the rapid flapping sound draws your attention. You see the words that you are now reading because the black ink draws your attention from the surrounding white paper.

Our attention is drawn by contrast because all of our senses are based on contrast. We survive by contrast. In any environment, our minds acclimatize or neutralize to the prevailing selection of sounds, brightness, tastes, etc., and quickly focus in on new sensual stimuli. Our senses evolved this way for survival. However since we acclimatize so easily, it is important to be aware of this process so as not to miss the obvious.

Our attention is drawn by contrast because all of our senses are based on contrast.

We survive by contrast.

Creating with light is purely visual and is therefore based on contrast. If we are to be truly free to create the visual treats we conjure up in our mind's eye, then we have to identify all areas of visual contrast and learn their controls and inter-relationships (so you might want to read on).

As photographers, we create two dimensional representations (photographs) of three dimensional objects. This basic concept is no different than that which many other artists do. For instance, an artist that sketches creates an illusion of depth by shading in certain areas of his or her drawing—creating contrast in relation to the

paper's tone. The white paper is the majority, whereas the ink is the minority. The minority always draws attention. The ink contrasts with the white paper. Consciously, we don't notice the paper, we only see the ink markings on it. Photography is similar; in order to enhance the illusion of depth on a two dimensional plane, photographers control the range of contrast with lighting.

■ AREAS OF ILLUMINATION

If a single light source is pointed at an object that is of one tone, at least three different densities on that object will occur. You will see

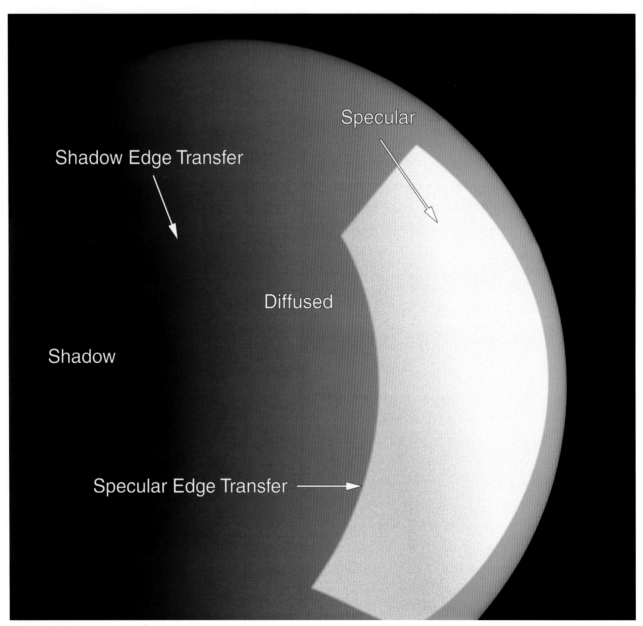

Diagram 1—The areas of light on a subject can be classified as shadow, diffused and specular. The areas of change between these regions are called "edge transfers."

the the subject's true tonality (called the diffused value) fully illuminated on the lit side, a bright reflection of the light source (called the specular highlight) on the lit side, and the true tonality underexposed (called the shadow) on the dark side. Lighting is made up of three distinct areas:

1. **Diffused.** This area represents the true tonality of the mass—the natural brightness of the subject. Also referred to as the diffused value. The diffused is objective. For instance the diffused value of the billiard ball (Diagram 1) is medium red. This medium red that we see is the actual color and tone of the ball. This information is objective; if we record it on film any other way, we would say that the image looks wrong.

2. **Shadow.** An underexposed area of the subject's diffused value that receives no illumination what-so-ever from the primary source of illumination. However, it may—and often is—lit by a secondary source (i.e. a fill light, or a fill reflector). Shadow is used to create contrast to the diffused value. It is subjective and can be made to appear any brightness darker than the diffused value. For instance, you might decide that the brightness of the shadow on the red billiard ball appears too dark or too light. This is a subjective observation, not an objective observation. You cannot say that this shadow is wrong, you can only say that you do or do not like it. How much attention the shadow draws can be controlled by altering shadow edge transfer—the rate of transfer from the shadow's tone into the diffused value's tone. More on this later.

3. **Specular.** This area is traditionally called shine, sheen, or hot-spot. It is a mirror image of a light source seen on the surface of the subject. It is also used as a contrast to the diffused value. Just like shadow, it is subjective, it can be made to appear any brightness brighter than the diffused value. Speculars, as do shadows, have edge transfers too, only these edge transfers govern how shiny a surface appears. This area of illumination will be discussed later in greater detail.

When lighting, all shadow and specular brightnesses are relative to the subject's diffused value.

Of course, this information all makes perfect sense as you sit here reading this book. But how does one apply these concepts when actu-

Quick Reference

Specular: Not to be confused with the term "highlight," the term specular refers to an area of brightness on a subject that is created by a bright reflection from a light source.

Shadow: This term describes an area of a subject that receives no light from the main light source. It does not describe areas of an image that are in the dark end of the gray scale but correctly exposed.

Diffused Value: The diffused value is the "true" tonality of the subject. Depending on the subject, this could include values from light (a white car) to very dark (a black dress).

ally lighting a real subject or object for photography? There are two steps:

1. **Find the Diffused Value.** Size up the subject, figure out what is the predominate diffused value. Is the subject's diffused value light, medium, or dark toned?

2. **Choose the Right Light.** Choose the appropriate light form to create contrast to the subject's predominate diffused value—either shadow or specular, or both. For instance it makes sense to shape a light toned object primarily with shadow, whereas specular light form would make sense on a dark toned object.

When lighting, all shadow and specular brightnesses are relative to the subject's diffused value. Think of the diffused value as the canvas and the specular and shadow as your paint. As I stated earlier, the diffused value is objective. For instance, a flesh tone that is actually a plus one brightness (one stop brighter than middle gray) should appear as a +1 value on film.

However, even this can become subjective if you decide for artistic reasons to over- or under-expose the flesh tone. A perfect example is the one to two stops overexposed flesh tones that are so common in editorial fashion photographs.

As for shadow and specular, they are totally subjective brightnesses. There is no correct exposure for shadow or specular. Their brightnesses can be made any degree darker than the diffused value (for shadow) and any degree brighter than the diffused value (for

Choose the appropriate light form to create contrast to the subject's predominate diffused value . . .

specular). The really cool thing is that their brightnesses can be controlled separately from the diffused value, but more on that later.

▥ CONFUSION AND CHAOS

If you have been in photography for a while, some of the above terminology may have you scratching your head. This use of the terms (which is rapidly becoming the standard for photographic lighting) was originally created and popularized by Dean Collins. Dean created this very concise vocabulary so that one term had only one meaning. This meant that photographers could analyze and communicate more easily, helping the photographic industry to develop at an accelerated rate.

So much of the traditional photographic vocabulary that many of still us use today to describe lighting is vague at best. Take for instance the following lighting terms that photographers love to bandy about: highlight, shadow, diffuse, specular, hard, and soft. Highlight is used to describe an area that is bright in value as in "the highlight side of the face." This terminology makes sense when describing the main-lit side of a face with a fair complexion, but falls flat when used to describe the main-lit side of a face belonging to a dark-skinned person. Yet, photographers still refer to the main-lit side of a dark-skinned person's face as the highlight side.

This somewhat makes sense, since this side is brighter than the shadow side of the face (making it stand out). Yet, it does not really make sense because these same photographers will tell you that the term "highlight" refers to the tones that inhabit the bright end of the gray scale (a scale of neutral colored tones that starts with black and incrementally increases in brightness until white is achieved). The tone created by a correct exposure of a dark skinned person does not fall into the bright end of the gray scale so we should not really call it a highlight.

A highlight is indeed a tone that resides in the brighter end of the gray scale, but what type of highlight is it? Is it regarded as a highlight because it is a light tone such as the paint on a white car? Or is it called a highlight because it is a bright reflection of a light source (a specular)? The terms we will use in this book are more specific. A highlight is the actual tone (diffused value) of a light toned object. A bright area on a subject created by a bright reflection of a light source is called a specular.

In the area of shadow formation, in traditional terminology photographers refer to the dark end of the gray scale as a shadow. In pho-

If you have been in photography for a while, some of the above terminology may have you scratching your head.

tography, as well as in the printing industry, the darkest area of a subject is often called a shadow. A black car fully lit and correctly exposed on film falls into the dark end of the gray scale. Is that car's dark tone then a shadow? No. This is because "shadow," by definition, means an area of the subject that receives no light from the predominant light source. A fully lit black object, such as our black car example, is not a shadow. It appears dark because its surface absorbs most of the light striking it, not because it is underexposed.

Picture a fully lit, pure black velvet dress. Is it a shadow or is it a black velvet dress? Well ask yourself this, "What is the subject's true tonality (diffused value), and is it correctly exposed?" Obviously, its diffused value is black, and to be correctly exposed it should appear black on the film. Something cannot be considered shadow if its diffused value is correctly represented on film. The diffused value of a subject is what it is—we don't need to change the "rules" just because it is a dark tone. If the tone of the object is underexposed somewhere on the object (it receives no light from the main-light), then (and only then) it is a shadow.

When describing the quality of light, photographers use terms like "specular" and "diffuse." The way these terms are used is often ambiguous. They use specular to describe the light quality produced by a small and/or distant light source. This is because a small and/or far away light source creates a high contrast specular (a harsh light quality due to a brighter reflection of the light source). On the other hand, a large and/or close light source creates a lower contrast specular (a more subdued light quality due to a dimmer reflection of the light source).

"Specular" merely means a reflection. All lights create speculars on subjects, but how bright or dim that specular appears is an issue of contrast (which I will cover in great detail later). To label high specular contrast light quality as just "specular" is, in my opinion, too vague. After all, specular refers to an area of light on a subject, not to a particular quality of light itself. For example, a diffuse light source means a light source that is diffused (its energy is spread out). Placing a piece of diffusion material (such as heat-resistant frosted acetate) over a light source does spread out the energy, but how much does this affect the light quality? Read on.

Picture a fully lit, pure black velvet dress. Is it a shadow or is it a black velvet dress?

Middle Gray: Middle gray (also called 18% gray) is the standard by which photographers compare all other tones in a photograph and set exposure. It is the midpoint tone on a scale of neutral tones starting at black and ending at white. Light meters are calibrated for middle gray, meaning that whatever diffused value they read, they indicate an aperture/shutter speed combination to make that volume of light appear as middle gray on film (even though that diffused value may not actually be middle gray).

For a correct exposure, a reflective meter reading is taken of a middle gray toned card (called a middle gray card or simply a gray card) placed against the subject. Since this reading gives you the aperture/shutter speed combination to make a middle gray card appear middle gray, then it stands to reason that all the other tones on the same plane and the same distance from the light source will fall into place relative to middle gray. In other words, a correct exposure will occur. You can also read directly off other tones in the image (instead of a gray card). For instance, by reading off the fully lit area on Leslie Nielsen's face, you can accurately predict how that tone will look on film. Imagine the camera was set at f11 at 1/60 second and the reflective meter gave a reading of f16 at 1/60 second. Since f16 is one stop brighter than f11, Mr. Nielsen's flesh tone would appear as a +1 value (one stop brighter than middle gray).

Reading off middle gray cards can be awkward, so most photographers use incident meters to set their exposure. Incident meters give the same information as a reflective meter reading off a middle gray card because the white dome or white flat disk on the incident meter absorbs the same amount of light as a middle gray card. The difference is, instead of placing a gray card against the subject then pointing the meter at it and taking a reading, you place the back of the incident meter against your subject, then point the white dome or disk at the light source in question and take a reading. In theory, the two readings should be identical. The beauty of the incident meter is, you do not need a gray card.

Either meter reading tells you how to set your camera to correctly expose your subject. This information does tell you how to get a correct exposure, but it does not tell you what the subject's tone is on film or in real life. Nor does it tell you how bright the background will appear behind the subject, or how bright the shadows or speculars will look on film. To do this, a second reading is needed. A reflective meter (no gray card) is pointed at the area in question. The reading it gives is then compared to the camera setting (which came from the incident meter or the gray card reading). If the shadow under Leslie's chin read f5.6 (reflective reading), this number should be compared to the camera setting of f11. F5.6 is two stops less light than f11. Since the camera setting f11 represents middle gray, then it is safe to say that the shadow will be a -2 value, its brightness will appear on film as two stops darker than middle gray.

Traditionally we have been taught that if you diffuse a light source, the resulting effect will be soft. When we say "soft" we are referring to lighting that has low contrast speculars and soft-edged shadows. Conversely, when we say "hard light" we are referring to lighting that has high contrast speculars and hard-edged shadows.

Imagine yourself as a wedding photographer about to take a photograph of the wedding reception head table. To fit the whole table

in your camera frame you have to back up some thirty feet away. Your main-light source is a flash mounted on your camera. This 2"x3" light source, you know from past experience, will produce lighting with a harsh look (bright glaring specular highlights and really hard-edged shadows). Wanting to subdue this effect, you place your handkerchief over the front of the flash so that the light energy has to pass through it. Will this help to soften the light quality on the subjects? It will, slightly, but you will be hard pressed to notice the difference.

To create low specular contrast and soft-edged shadows you need to work with a large light source in close. But how large? How close? That is relative. Imagine lighting a small object such as a 35mm film roll canister. Your 2"x3" light source with its hanky cover is a relatively large light source compared to this subject (if it is placed relatively close to it). However, the same light source would be relatively small if it were used to light something larger (such as an automobile). To produce the same quality of light, at the same distance, on an automobile instead of the film canister, this light source would have to be enlarged to somewhere in the neighborhood of 20'x30'.

■ THE DIFFUSED VALUE

The diffused value is the true tonality of the subject. For example, the natural brightness of Leslie Nielsen's skin (see Frame 1, *Lord of the Violin*) is roughly one stop brighter than middle gray (see page 13). This brightness is objective. To alter it would be to alter reality (and this image is just brimming with reality), resulting in an image that you would perceive as over- or underexposed. Our job as photographers (in

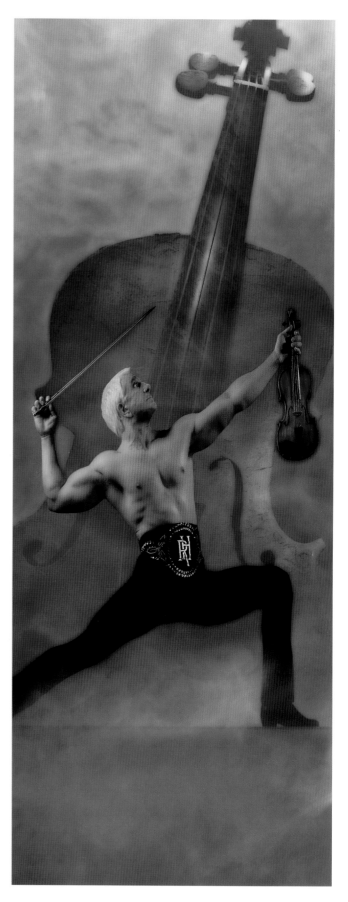

Frame 1

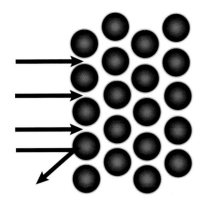

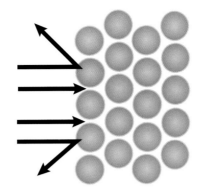

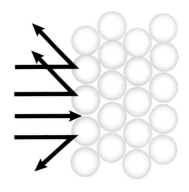

Diagram 2—Very little light bounces back from the loosely packed molecules of a dark subject

Diagram 3—Some light bounces back from the more tightly packed molecules of a medium subject

Diagram 4—Much light bounces back from the tightly packed molecules of a light subject

theory) is to expose the subject correctly, so that the diffused value is properly represented on the film.

When particles of light from a light source strike the subject's surface, many of the particles will enter the molecular structure (see above). If the molecular structure of that surface is porous (such as the molecular structure of the black dye in Mr. Nielsen's pants), meaning that the molecules are held together by elongated strands, then the particles of light will penetrate deep into the molecular structure. A deeper penetration allows fewer light particles to bounce back out of that molecular structure, creating a darker tone.

If the molecular structure is very tight, very condensed (such as Mr. Nielsen's light-colored hair), then the particles of light will not be able to penetrate as deeply and a greater number will bounce back out of the structure, creating a lighter tone. When the light energy bounces out of the molecular structure it spatters out in 180 degrees, hence the term "diffused."

Not all molecular structures absorb the full spectrum of light evenly. The violin in Mr. Nielsen's hand is perceived by our minds as being a warm brownish color. It appears this color because the wood and the wood stain's molecular structure is such that it absorbs mostly the cool wavelengths of the visible spectrum of light, returning only the warm colors that make up brown wood.

There are some surfaces that have no diffused value: clear liquid, glass, and metallic surfaces (like the chrome beads in the monogram on Mr. Nielsen's belt). With clear liquid and glass, most of the light passes through the molecular structure so that the tone you create contrast to is the tone that you see behind or beneath the subject.

Chrome is different. Its molecular structure is so condensed that no light enters the molecular structure. It all bounces off the surface. A chrome surface's true tonality is whatever it happens to be reflecting. For example, if the chrome surface were in a white room, the chrome would appear white. To bring out its shape, it therefore makes sense to place dark toned things such as black paper around it that will contrast with the white reflection of the room on its surface. If the chrome surface were in a dark colored room, the chrome would appear dark. To bring out its shape it makes sense to place light toned things such as white paper around it that will contrast with the dark reflection of the room on its surface.

When lighting Mr. Nielsen, the main-light was placed to create a mask of light on his face. That mask of light is illuminating his face to its true tonality. However, there's more than one true tonality present on his face. The flesh varies slightly in color and tone from one area to another, plus his face is made up of not only flesh, but of eyes, eyebrows, and lips. All these parts of the face have different diffused values. But do not fret, a multi-toned subject like Mr. Nielsen is just as easy to deal with as a single toned object like the red billiard ball. Since all these tones are roughly the same distance from the source that we are metering for, they will be correctly reproduced simultaneously.

A chrome surface's true tonality is whatever it happens to be reflecting.

Forming with
Shadow

▓ SHADOW

In the image of the billiard ball on page 8, the side that is opposite the light source receives no illumination from the main light. The light is blocked or shaded from this area by the other side of the ball. This dark side of the ball is said to be in shadow. A shadow is an area of the subject that receives no light whatsoever from the main source of illumination. However, it may receive some light from an extraneous ambient source (e.g. fill light, fill card, open sky). The shadow is always a fraction of the brightness of the diffused value. That is to say, it is always darker than the diffused value on the lit side.

In lighting we predominantly use shadow to show shape and form on mid- to light-colored objects. To show shape and form on an object that is black, what would you do? Can a shadow exist on something that is black? Would there be any contrast?

In lighting we predominantly use shadow

to show shape and form

on mid- to light-colored objects.

Look at the image entitled *On Edge* (Frame 2). Where is the shadow on the ball's surface? We perceive the ball to be black because it absorbs almost all the light striking it and returns almost none. In theory, black is the absence of light. Shadow is an underexposed area, but when *black* is underexposed it still appears black. In other words, you can't make true black look any darker than it already is. Visually, a shadow cannot exist on a black diffused value. If the tone were dark gray, it would be possible to produce a shadow. However, there may be little tonal room to create noticeable contrast. It makes sense that speculars are better suited to creating shape and form on dark- to mid-toned subjects and that shadow is better suited for mid- to light-toned subjects.

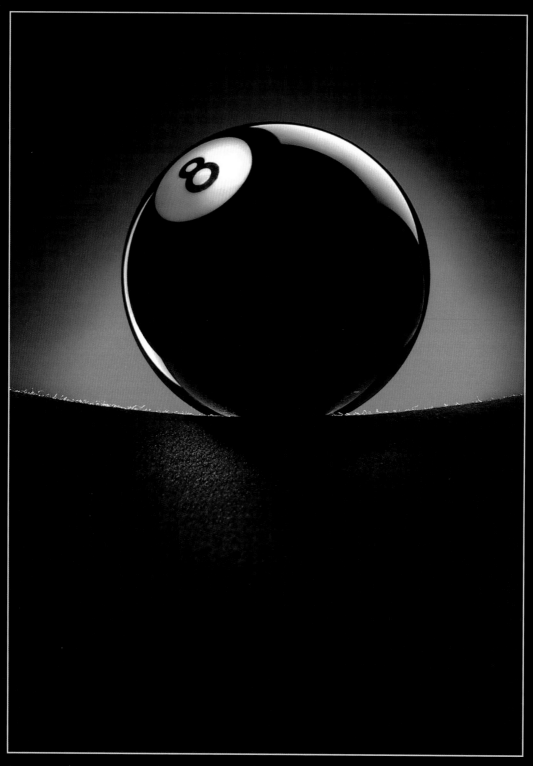

Frame 2—This image is entitled "On Edge." Where is the shadow on its black surface? We perceive the ball to be black because it is absorbing almost all the light striking it and returning almost none of it.

To effectively create shape and form on subjects with shadow, you must understand its two areas: shadow edge transfer and shadow contrast.

▌ GLAMOUR LIGHTING WITH A DRAMATIC EDGE

For a photographer trying to go professional, there is a nasty "Catch-22" lying in wait. You can't get the work you want because you don't have the equipment, and you can't get the equipment because you don't have the work to pay for it. But there is a practical solution to this common dilemma: specialize in an area where you can do high volume and use a minimal, yet versatile, lighting setup (an inexpensive/homemade setup).

One such area is head-shots of actors and models. This is not a highly paid area of photography, but can generate a reasonable profit if done quickly, and in volume. Start by making yourself known to modeling and acting schools. Give the school a price break that is tiered (i.e. the more students they sign up for the photo shoot, the lower the price per head).

On a prearranged day, you shoot ten to twenty people back to back, using the exact same setup. Since these kinds of head-shots are done in black & white, you can get away with using an inexpensive tungsten light. A winning combination is 400 ISO fine grained black & white film with an inexpensive, 500 watt security or workman's light (with stand) from the local hardware store. A 500 watt light is plenty of power at f5.6 and $^1\!/_{15}$ second on 400 ISO film. Make sure you use a tripod to eliminate camera shake from slow shutter speed.

The image of Sylvianne with sunglasses is a perfect example of a glamour portrait with a dramatic edge. The beauty of the lighting setup in this image is that multiple light sources are created from one 500 watt workman's light. In other words, you only have to buy one light. There are also some "quick change" background ideas for variations that can be performed in seconds on the fly. These go over very well, since buyers of your subject's talent want to see what he or she looks like against different background tones.

In frame one (next page), Sylvianne is lit by a small and relatively distant light source (a 500 watt "workman's light" tungsten lamp). The quality of light is hard, with hard shadow edges and high specular contrast. Some of the light is spilling past her onto the light gray wall background. Both the background and the lit side of her face are illuminated to their proper tonal values. The exposure is f8 $^5\!/_{10}$ at $^1\!/_{15}$ second.

. . . multiple light sources are created from one 500 watt workman's light.

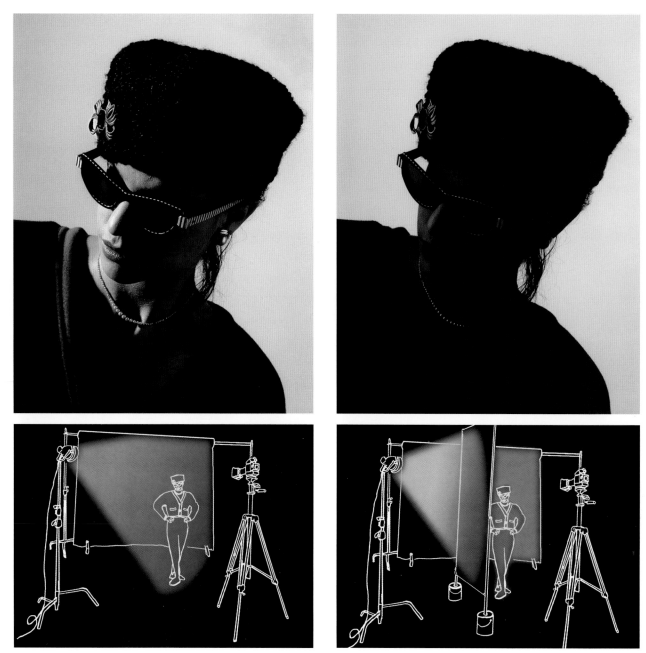

Frame 3

Frame 4

In Frame 3, a 6.5' x 3.5' diffusion panel (constructed of inexpensive ¾" PVC irrigation tubing with white nylon stretched over it) placed between the light and Sylvianne greatly increased the effective size of this main light source. The entire panel is now considered the main source of illumination, and the tungsten lamp is considered the origin of the source. The panel was placed close to Sylvianne (just out of camera frame), making its relative size to her larger still. By increasing the size of the main light source and placing it in close to her, a much softer light quality (soft-edged shadows and low contrast

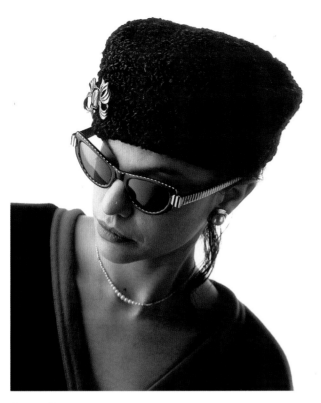

Frame 5

✔ *Data for Frames*

FRAMES 5, 6, 7 AND 8:

Exposure: f5.6 at 1/15 second

Camera: Hasselblad ELM (medium format camera)

Lens: Hasselblad 150mm

Film: Kodak T-Max 400 rated at 320 ISO (black & white)

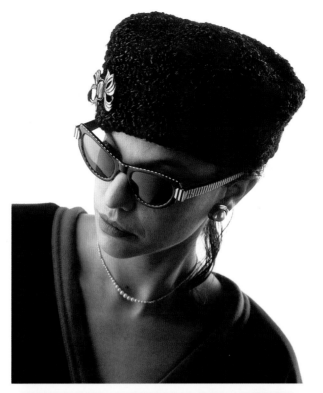

Frame 6

speculars) was created. The panel was placed and angled in such a way that it only affected the light striking Sylvianne. Compare the background brightness between frame one and frame two. Each is identical. The background brightness has not changed at all because the panel does not block any of the 500 watt light from the backdrop. However, the panel does reduce the light intensity on Sylvianne, thus underexposing her.

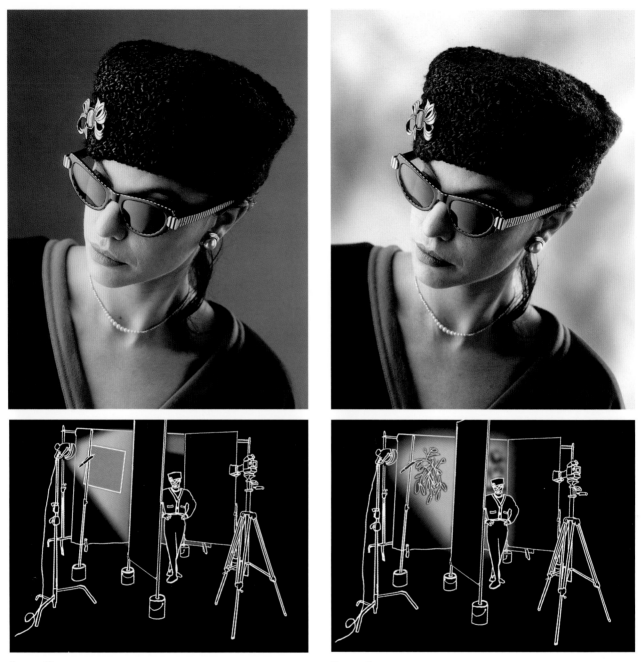

Frame 7

Frame 8

In Frame 4 (previous page), after re-metering, the lens aperture was opened up to f5.6 to compensate for the light loss on Sylvianne. She is once again properly exposed. However, at f5.6 the background is overexposed by 1½ stops. It now records on film as pure white—white without detail.

In Frame 5 (previous page), the addition of another panel with silver lamé stretched over it creates subtle separation lighting. This panel reflected some of the raw light spilling past Sylvianne onto the rear edge of her body. An incident meter placed against the back of

Sylvianne, with its dome pointed toward the silver panel, reads f2.8 at $^5/_{10}$ second. The light striking Sylvianne from this source reads 1½ stop less light than the light striking her from the main-light panel.

In Frame 7, for a quick-change background variation, a piece of cardboard was carefully placed to block only the light from the background. A reflective meter reading (f2.8) off the background read two stops darker than the camera setting creating a dark gray (−2) background. The camera setting always represents middle gray (see page 13).

In Frame 8, for yet another quick-change background variation, the cardboard "gobo" was replaced with a tree branch full of leaves. The resulting leaf shadows create a background that looks like a skyscape.

In Frame 9, to create smoother looking skin on Sylvianne's face (to make this more a glamour shot than a character shot), the image was scanned and retouched (in less than ten minutes) in Adobe

Frame 9

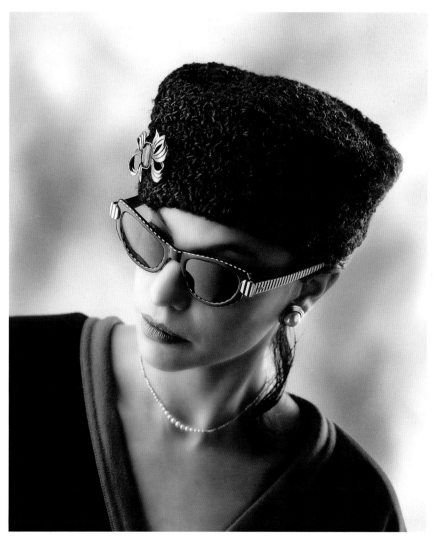

Photoshop. The retouching method is as follows. First, copy the background layer (drag it to the turning page icon at the bottom of the palette). Apply a heavy Gaussian blur to the copied layer (Filter>Blur>Gaussian blur). The image becomes very out of focus. Next, take a snapshot in the history palette (click on the turning page icon at the bottom of the palette). This records the current blurred state of the image. Undo the Gaussian blur (Edit>Undo); the image will appear sharp again. Click on the little box next to the blurred version snapshot in the history palette to select this as the state to work from (the image will still appear sharp). Next, select the history brush from the tool palette and change to mode from "Normal" to "Lighten." Brush over the face, avoiding the eyes, lips, nostrils, etc. The blurring smoothes out the texture. Sylvianne's face in the photo is a light gray, while the unwanted texture is a darker gray. Setting the history brush to "Lighten" means it will only blur the dark into the light. This creates subtle, but effective retouching. Since the retouching is on its own layer, you can reduce the final effect by altering the layer's opacity (click on the 100% at the top of the layers palette to bring up a slider, then adjust this slider to allow more of the un-retouched image to show through).

The beauty of this simple background system lies in the fact that the photographer's concentration and the rhythm of the shoot are not interrupted. In a matter of minutes you have provided your subject with a variety of backgrounds and are on to the next person. Setting up ahead of time (placing and metering the shadows before the first subject arrives), is the trick to making this technique successful.

In a matter of minutes you have provided your subject with a variety of backgrounds . . .

Quick Reference

Source of Illumination: The source of illumination is the immediate source from which light falls directly on the subject. When using one unmodified light, this light is the source of illumination. If a panel is added between the light and the subject, this panel becomes the source of illumination.

Origin of the Source: This term describes the original source of light. When using one unmodified light, this is the origin of the source (as well as the source of illumination). If a panel is added between the light and the subject, the light remains the origin of the source (but the panel is now defined as the source of illumination).

Looking back at frame one and frame two or three, the source that lights your subject, called the source of illumination, is critical. Its relative size and its relative distance from the subject have a profound effect on the light quality we see on the subject. The main source of illumination on Sylvianne in frame one is the tungsten lamp. The tungsten lamp is also the origin of the source. It is where the energy originates from. In frame two or three notice how the light quality has changed by adding the panel. The tungsten lamp is no longer lighting Sylvianne because it is blocked by the fabric. However, a lot of the light is transmitting through the fabric (and is altered by it) onto Sylvianne. In this image, the fabric is the main source of illumination. It is the source that lights Sylvianne's diffused values to their correct brightnesses. The tungsten lamp is the origin of that source. It is important to differentiate between source and origin because it is the actual source that affects how the light looks on your subject.

It is the actual source that affects how the light looks on your subject.

A PANEL DISCUSSION

Panels, sometimes called flats or scrims, thingys or what-sa-ma-call-its, are common in the film industry and gaining popularity in photography (even though they have actually been in use in photography for many years).

Construction of these panels is simple and inexpensive. Probably the best material is PVC irrigation tubing or piping. It is strong, easy to cut, inexpensive, and readily available at irrigation and plumbing supply depots. The most popular tubing size, which balances cost against strength, is ¾" (inner diameter).

Begin with a twenty foot length cut into four pieces. First, cut the 20' length in half, then cut 3.5' off the resulting 10' lengths (yielding two 6.5' lengths, and two 3.5' lengths). The four lengths fit together making a rectangle. Join the ends together with ¾" inner diameter 90° PVC elbow joints (also bought at the irrigation and plumbing supply depots). The 6.5' x 3.5' dimension is a good size for lighting people and has become the standard size for photographic panels. However, for full length images a taller panel is better (10' x 3.5'), since this will provide better light dispersement over the subject. Other common sizes are: 6.5' x 6.5' (good for lighting larger objects and group portraits); 3.5' x 3.5' (for head-shots and smaller objects). If you construct two of the standard size, they can be dismantled and reassembled as a 3.5' x 3.5' panel and as a 6.5' x 6.5' panel.

For diffusion and reflective material, purchase white nylon fabric from fabric stores. It can be cut and sewn to the dimensions of the panels. The white fabric is secured to the frames with 5" elastic strips sewn diagonally across the panel fabric corners. The elastic strips pull over the panel frame holding the diffusion fabric tightly in place. For blocking light, use black nylon. For a very bright reflector, use silver lamé. To reduce the light transmitting through the panel, use two layers of white nylon. However, be forewarned, the more diffusion fabric layers you add, the "warmer" (slight shift in color towards yellow) the image becomes. I never use any more than two layers.

▧ SHADOW EDGE TRANSFER

If light from the main light spills into the shadow area, it is no longer considered a shadow. Instead, it is considered the transfer area. This is the area where the light transfers from the true tonality (the diffused value) into the true shadow.

Our senses are very sensitive to rates of transfer. How much you notice a transfer will be dependent upon the actual rate of change. For instance, if you walked into a kitchen and the refrigerator was making a loud humming noise, it would draw your attention. However, your sense of hearing (as all our senses do) would acclimatize to the sound after a few minutes. If it increased in volume over the span of one second (a rapid transfer) it would immediately draw your attention. If it were to increase in volume over a period of an hour, you probably wouldn't notice the change at all.

The same is true with vision when you are lighting. If the edge of the shadow transfers over a larger area, it becomes less noticeable. This is a particularly good thing to consider when lighting people. In portraiture, unlike fashion, photographer's subjects are usually regular people. Regular people tend to have less than perfect flesh—they have bumps and wrinkles on their faces. On darker skin tones, the shape and form is revealed more by specular than by shadow. On lighter skin tones, shape and form is created more with shadow than with specular. As a result, when photographing lighter skin tones, wherever there is a bump or wrinkle, the resulting shadow is very noticeable against the light flesh.

If you are able to make some of the main light see around into the shadow, a softer rate of transfer will occur, and this will create a softer edge. A softer rate of transfer draws less attention, making the shadow less noticeable. If you do not notice the shadow you will not notice the wrinkle. Therefore, creating a gradual transfer from a shad-

If the edge of the shadow transfers over a larger area, it becomes less noticeable.

ow into the diffused value helps reduce the need for retouching in your portraiture.

For example, in frame one of Sylvianne (on page 20), look at the rough textured flesh on her neck on the edge of the shadow. Compare this with the same area on frame two of Sylvianne (page 20). In this image, the texture is less noticeable because the larger light source has eaten further into the shadow and created a softer shadow edge transfer. Soft shadow edge transfer is part of soft light. The edge of the shadow transfers very slowly into the diffused value. In a hard shadow edge transfer, the shadow edge transfers rapidly. Think of it this way: a soft edge appears fuzzy, and a hard edge appears sharp.

There are four ways a photographer can control shadow edge transfer:

1. Size of light source
2. Distance of light source
3. Obstruction distance
4. Motion of source

SIZE OF LIGHT SOURCE

Changing the size of a light source affects shadow edge transfer (as we observed with the shadow on Sylvianne's neck). If a main light were enlarged by four times, the main light would see four times further into the shadow (the shadow edge transfer area would cover a four times greater area).

A light source is visually two dimensional. It is made up of height and width only. You can create two different rates of transfer with one

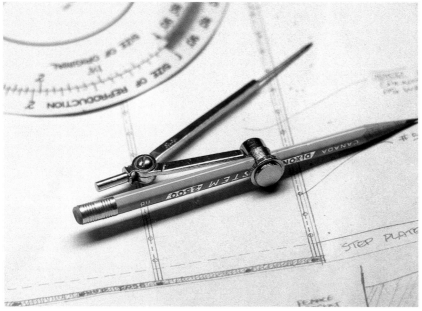

Frame 10

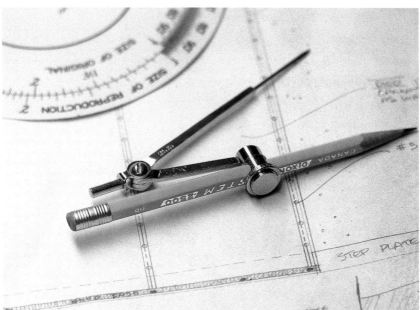

Frame 11

light source by choosing a light source made up of two different dimensions. A "strip light" (a very skinny rectangular light source) does exactly this. It is a small light source in one direction and a larger light source in the other direction. The image "Compass and Pencil" (on the next page) is a perfect example of strip lighting.

In Frame 10, the compass and pencil are lit by a 6' x 1' strip light made from a Chimera 6'x4' softbox with a White Lightning Ultra 1800 studio strobe light placed inside. The softbox width was reduced from 4' to 1' by attaching two 1.5' x 6' strips of black seamless paper over the white diffusion material on the front end of the softbox. The material was placed parallel to the pencil, generating

Data for Frames

FRAMES 10 AND 11:

Exposure: f16 at 1/60 second

Camera: Hasselblad ELM

Lens: Hasselblad 150mm

Film: Kodak Ektachrome 100 Plus rated at 80 ISO (daylight
balanced transparency film)

Tech Tip

When lighting a person's face, you can vertically orient the long side of a rectangular light source to help slim the subject's face. To give the subject's face a fuller appearance, orient the rectangular light source horizontally.

soft shadow edge transfer on the eraser end of the shadow under the pencil. At the same time this light source creates a harder shadow edge transfer on the sides of the shadow.

In Frame 11, the softbox strip light has been rotated so that it is positioned perpendicular to the pencil. Now more of the softbox is seeing around the sides of the pencil and into the pencil's shadow below. This generates a softer shadow edge transfer through the shadow. This positioning of the light source also creates a harder edge transfer on the end of the pencil's shadow. Placing the light source perpendicular to the pencil has totally transformed the shadow. In fact the shadow has ceased to exist! The light source can now see into all parts of the shadow area under the pencil. Since a true shadow receives no illumination whatsoever from the main light source, then there is no true shadow under the pencil. This whole area is now considered shadow edge transfer.

Remember, a small light source creates harder lighting. A large light source creates softer, wrap-around lighting.

DISTANCE OF LIGHT SOURCE

If you wanted to change shadow edge transfer, but could not alter the size of the light source, you could alter its "apparent" size by changing its distance from the subject. A light source can be made to appear larger by decreasing its distance from the subject, and smaller

by increasing its distance to the subject. If you wanted to make the edge of the shadow transfer over less area (let's say one quarter of the area), simply double the distance of the main light to the subject. From the subject's point of view, the light source appears smaller. This relationship is described by the inverse square law. That is:

1. Measure the change in distance (say, to 2' from 1') and describe it as a fraction (here, $^2/_1$).
2. Invert the fraction (now $^1/_2$).
3. Multiply it by itself (square it). Here:
 $^1/_2$ X $^1/_2$ = $^1/_4$.

Doing this calculation reveals that the light source would now appear to be $^1/_4$ of its original size to the subject. As a result, the shadow edge would transfer over $^1/_4$ of the original area making the lighting appear harder. The smaller the light source appears to the subject, the harder the lighting appears.

In Frame 12 a $3^1/_2$' x $3^1/_2$' white nylon covered panel with a White Lightning Ultra 1800 studio strobe light firing through it, was placed to Anna's side some three feet away. This main light source distance is considered relatively close. Notice how soft the shadow edge transfer is.

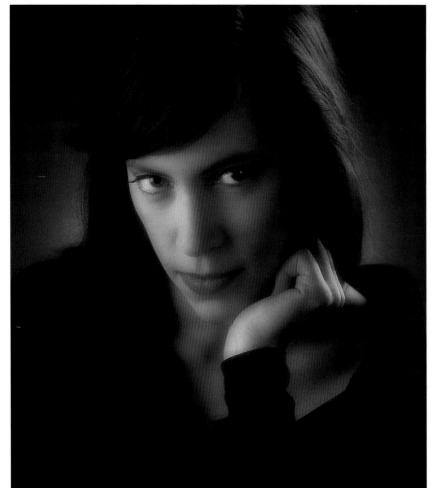

Frame 12

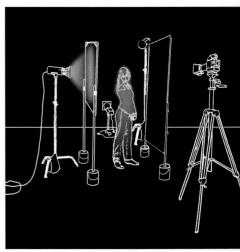

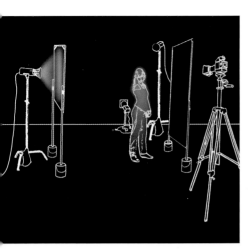

Frame 13

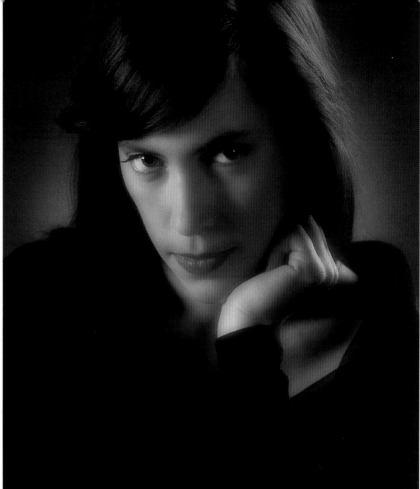

FRAMES 12 AND 13:

Exposure: f8 at 1/60 second
Filtration: Wratten 81A on front of lens
Camera: Hasselblad ELM
Lens: Hasselblad 150mm
Film: Kodak Ektachrome 100 Plus rated at 80 ISO

In Frame 13, wanting a harder shadow edge transfer, the main light was repositioned some six feet away from Anna. At double the distance, the main light creates a harder-edged shadow.

To better understand how distance of the light source affects shadow edge transfer, let's imagine for a minute that Anna is a massive woman, a veritable mountain of flesh—so big that it would be possible to scale her face, as though it were the summit of Mt. Everest. You carefully inch your way across her cheek's treacherously smooth complexion, fighting for foot and handholds. After a few near fatal slips you find yourself in the shadow caused by her nose. As

Diagram 5

Diagram 6

you look up across her nose, you notice that the main light softbox is nowhere to be seen. You are in the "true" shadow area (remember the definition of true shadow—an area of the subject that receives no illumination whatsoever from the main light source). It stands to reason if you stand in the area that is in shadow, then the main light will not be visible.

Looking back at the way you came, you notice a triangular patch of light around her eye. With the utmost caution you claw your way towards this main-lit area, ending up under her eye. Looking up across her nose, you now see the main light softbox, in fact you can see the whole thing. You see it because you are in an area that is fully

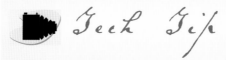
Placing your light source close to the subject creates a softer edge transfer. Placing your light further away from the subject creates a harder edge transfer.

lit by the main light source—the whole light source must be visible to this area for this area to be fully lit.

If the camera exposure is set to correctly expose the light striking the subject from the main light, then all areas that "see" the whole light source will have fully lit/correctly exposed, diffused values.

If you were to inch your way over to the shadow caused by Anna's nose, stopping on that shadow's edge, you would notice that only part of the main light softbox would be visible—less softbox is visible as you move closer to the full shadow, more softbox is visible as you move back towards the fully lit area. Obviously with only part of the softbox seeing an area, that area would neither be fully lit nor would it be totally shaded. It is of course a transfer area where the diffused value moves into shadow. This transfer area is called shadow edge transfer.

As you look over Anna's nose with the softbox in close, you see a good portion of the softbox (figure one). This results in the shadow edge transfer that we see in Frame 12. If the softbox is moved further away you see less of it. This would correspond to Frame 13 of Anna. The whole point is, as the source sees further into the shadow, it eats further into that shadow creating a gradual transition from diffused to shadow. As the source sees less into the shadow, it eats away at that shadow less, creating a smaller transfer area. The smaller the transfer area, the harder the lighting appears.

Portrait photographers tend to use the same lighting setups for each subject. However, every subject is unique, and each subject has different surface characteristics that need to be analyzed individually before deciding on the appropriate light quality to compliment those characteristics and create the appropriate mood. For instance, in this image of Anna, I wanted to create a glamour shot with a dramatic shadow, and I wanted to draw attention to that shadow. The best way to draw attention to shadow is create a short rate of transfer between the diffused and the shadow (a hard shadow edge transfer). On the average person, harder lighting (when not retouched) is usually not very complimentary. With Anna it was different because she has a

very smooth complexion. This allowed me to work with harder lighting and avoid retouching.

A more common main light position for glamour lighting would have the main light in a more frontal position. For my taste (in this shot at least) a frontal position lacked the drama and character that side lighting could give me. You see, I like to accentuate facial characteristics and add some character to glamour images that might otherwise end up as vacant beauty shots. Anna has a long face that I think gives her character. The side position of the softbox helped to accentuate Anna's long face by creating "short lighting." This means, when Anna turns her face into the light, the mask of light on her face is oriented away from the camera, and the shadow side of her face is towards the camera (which is to say, the main light falls primarily on the less visible half of her face). Short lighting creates a thinner looking subject. It does so by "slimming down" or compressing the amount of main lit area that the camera can see.

▥ OBSTRUCTION DISTANCE

Ever notice that on a sunny day the shadow cast by a telephone pole has a harder shadow edge transfer at the base of the pole and a softer shadow edge transfer at the top? You probably have not, but you will now. This nifty fact can save you lots of money on backdrops if you employ the principal involved into your lighting.

Shadow edge transfer is affected by the distance of the "shadow causing" obstruction from the surface that the shadow lies upon. An obstruction set close to a surface will create a hard-edged shadow on that surface, whereas an obstruction that is placed further away from the surface, will create a softer-edged shadow.

In *Peter Loychuk: A Ukranian Pioneer* (Frame 14), the background appears to be painted canvas. Actually, it is a plain, light gray wall with lighting effects that simulate a painted canvas. Controlling shadow edge transfer is the "trick" that makes it look like a top-quality backdrop. Lesser quality painted canvas backdrops usually have harsh gradations or transfers from one tone to the next, whereas quality painted canvas backdrops generally have much softer transfers. This soft edge transfer draws less of the viewer's attention from the subject plus it creates the illusion of depth in the background.

In real life (as opposed to "fake" life—photographic illusion of three dimensional depth on a two dimensional plane), our minds help separate the subject from the background by mentally creating higher contrast on the subject and lower contrast on the surroundings.

This nifty fact can save you lots of money on backdrops . . .

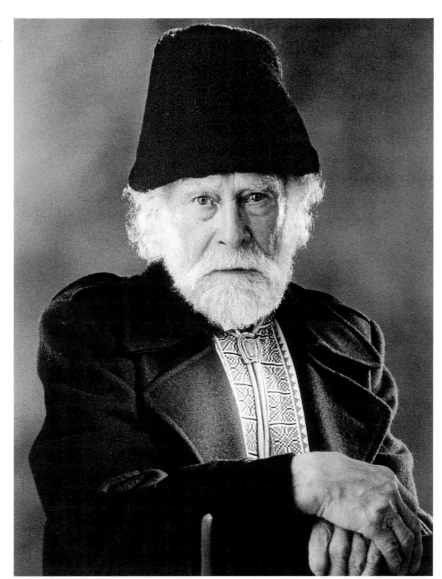

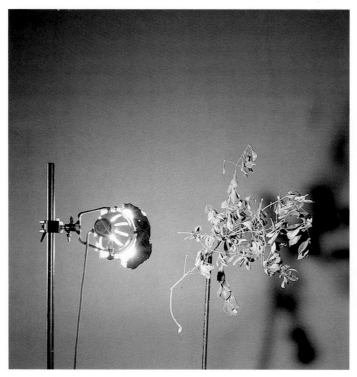

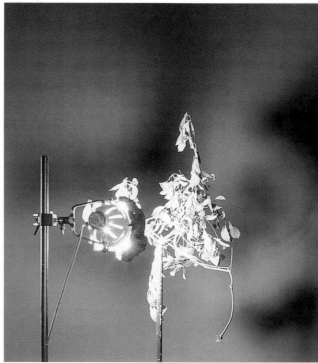

Frame 15

Frame 16

Also, our eyes render the subject sharp and the surroundings somewhat softer. Wanting to mimic this look, I created soft-edged shadows on the wall behind Peter. The effect is the same as seen in Frame 8 of Sylvianne (on page 22), where a tree branch full of leaves caused shadows on a background. The control for shadow edge transfer employed on the background behind Peter is called "obstruction distance." This means that the shadow edge transfer of the leaf shadows on the wall behind Peter were controlled by changing the distance of the leaf obstructions from the wall.

In Frame 15, the leaf shadow background was created by placing the tree-leaf obstruction in between the light source and the background, shadows are formed. Since the obstruction is relatively close to the background, the shadows appear harder-edged and smaller.

In Frame 16, a leaf shadow background was created by moving these obstructions further away from the background (and closer to the light source). This made larger shadows with softer edge transfers, perfect for faking a canvas backdrop behind Peter.

■ TRY IT OUT

To see the effect of obstruction distance for yourself, close one of your eyes and place your open eye (represents the wall) about three feet from a lit lightbulb (represents the light source). Hold your index finger (represents the leaf obstruction) two to three inches in

Since the obstruction is relatively close to the background, the shadows appear harder-edged and smaller.

front of your open eye. Position it so that it blocks most of the bulb. Keeping your head stationary, slowly move your finger towards the bulb. Notice how the finger shrinks in size allowing you to see more of the lightbulb. This is how the light source can eat away at more of the shadow when the obstruction is moved away from it.

Now, before you go charging off to try this background trick (all excited thinking about the money you are going to save), you would be well advised to read on a little further. You see, there is more to making this work really well than just plopping down a bunch of leaves at the correct distance. The softness of the shadow edge transfer is actually governed by four things:

1. The distance of the light source
2. The distance of the obstruction
3. The distance of the background
4. The size of the light source

All four factors are relative to one another. If you change the distance of any of the first three, the edge of the shadow will be altered. That, by now, should be pretty obvious to you. However the fourth probably isn't obvious, and that is the one that can really screw you up. You may well find that the edges of the shadow are not getting particularly soft as you move the leaves away from the background towards the light source. On top of that you may be get multiple shadow edges of varying darkness instead of one big fat shadow edge. This is caused by using too small a source. Assuming that you are using an undiffused light with a reflector on it, your source is quite small. Therefore, moving the leaves away from the wall toward the light makes only a slight difference.

Quick Reference

Obstruction Distance: The distance of an obstruction from the surface on which it casts shadows controls the shadow edge transfer rate (obstruction close to surface = hard shadow edge transfer, obstruction far from surface = soft shadow edge transfer).

Inverse Square Law: First, measure the change in distance (say, to 2' from 1') and describe it as a fraction (here, 2/1). Then, invert the fraction (now 1/2). Finally, multiply it by itself (square it). Here: 1/2 X 1/2 = 1/4

The gain in edge transfer area is governed by the inverse square law. If you increase the distance of the obstruction from the background, say double the distance, the edge of the shadow will cover a four times larger area. If the shadow edge, to start with, transfers from shadow into the diffused value over a 1mm width, doubling the distance will result in only a 2mm width. This is still a really small area, and not much of a change relatively speaking.

But, if you were to increase the size of that light source, more of the light source could see around the leaves and into the shadow. This would create a larger transfer area. If you are thinking, "Let's stick that light in a softbox or behind a panel," think again. A standard softbox or panel would actually be too large, creating a huge shadow edge transfer and eliminating most of the shadow effect.

I generally place a piece of frosted acetate (a type of light source gel called Tuff Frost by Roscolux, also made by Lee, available at larger photo stores and at motion picture or stage supply houses) over the light, such as a strobe head or a hotlight. This increases the size of the source by a reasonable amount.

This frosted acetate also solves the problem of multiple shadow edges by turning the strobe head or hotlight into a single light source. A silver parabolic reflector, as is standard on strobe heads, creates multiple light sources because the bulb (or strobe tube) of the light bounces off the reflector in multiple spots. One piece of frosted acetate over the front turns several light sources into one source, creating only one shadow edge. (One strobe manufacturer, Paul C. Buff Inc., uses a frosted photoflood bulb instead of the usual smaller quartz halogen tungsten bulb, for a modeling light. The light from the strobe tube and from the reflector passes through this bulb making a larger single light source. The final result is a source that sees

The gain in edge transfer area is governed by the inverse square law.

further around the leaves, eating away at more of the shadow, gradating the edge over a larger area.)

There's still one final "gotcha" to look out for: depth of field. Always view the background through the camera with the lens stopped down to the shooting aperture and with the depth of field preview engaged. Be aware that the shadow edges that you created on the background may appear different inside the camera. It is possible that, if you are shooting with shallow depth of field, you could end up with a near solid single tone background on film. If the depth of field is really throwing the background out of focus, then create harder-edged shadows to counter the extra unwanted softness.

■ MOTION OF SOURCE

Shadow edge transfer can also be affected by a moving light source. By making the light cover a larger area, shadow edge transfer softens. Motion of source is a control that not a lot of photographers think about. Really, it is what we call painting with light. Motion of source was the solution that saved my bacon in a very delicate situation—a very important client needed a "rush shot" of some car parts on a white background (see Frame 17).

The problem was, they needed color transparencies (slide film), and they needed them by the end of the day. We were already in the midst of a rather large project that had most of our lighting equipment and studio tied up for the next few days. This client was too

FRAMES 17 AND 18:
Exposure: f8 at 4 seconds
Camera: Hasselblad ELM
Lens: Hasselblad 80mm
Film: Kodak EPT 160T (tungsten transparency film)

Motion of Source: Movement of a small light source can over a period of time create a larger source. The different positions of the light source during this "light painting" movement will allow the small source to see further into the shadow creating a softer shadow edge transfer.

Frame 17 (image and setup shot directly above)—The small light source (a 650 watt "Red Head" tungsten hot-light) creates relatively hard-edged shadows under the car parts.

Frame 18 (image and setup shot directly above)—By waving the light source back and forth during a time exposure, the source becomes larger, creating a softened shadow edge transfer.

important to future business to be turned away, so we squeezed the shot in over lunch hour when the art director from the other shoot was out.

The next problem that needed to be solved was lighting equipment. All the equipment we had left to work with was a 650 watt tungsten hotlight (in other words, a very small light source). The designer for the car parts company requested soft "drop shadows." To create soft shadow edge transfer, we know that a small light source cannot cut it—unless we can somehow make that small source work like a large one.

Since we were out of equipment, there was only one solution: the fourth dimension (time).

Since we were out of equipment, there was only one solution: the fourth dimension (time). The light source, though small in size, could be made to eat away at the hard shadow edges over a period of time. With this in mind, I had my brother/partner Mark stand over the car parts (which he had spread over a white seamless paper lying on the studio floor). During a four second exposure on tungsten film, he moved the hotlight back and forth over a five foot area above the subjects (see Frame 18). The areas of the subjects that saw the whole light source the whole time during the exposure were correctly exposed. The areas that did not see the light at all were in shadow. The areas that saw the light source for part of the exposure were in the transfer zone (the shadow edge transfer). The edge transfer from diffused into shadow appeared relatively soft because the light source was moved over a relatively large area.

Tech Tip

Drop shadows are simply shadows on a background around the subject. Their purpose is to visually anchor the subject to the background. Without shadows, the subject would look as though it were floating. The word "soft" that the designer used was important to clarify. In lighting, "soft" refers to an edge transfer that gradually changes tone over a larger area. However, clients, designers, art directors, and even other photographers use the words "soft" and "hard" to describe not only shadow edge transfer but also shadow contrast. If a shadow is dark, they will often say that it looks hard even if it has a soft edge transfer. They may also say that a light shadow is soft, even though it may have a hard edge transfer. So it is important to clarify. Ask the question in layman's words, "Do you want the edge of the shadow fuzzy or do you want it crisp? Do you want the shadow to appear darker or lighter?"

In the image *Fallen Angels* (Frames 19–22), much of the dramatic impact comes from the lighting. How do you interpret the word "dramatic" into lighting? Imagine what the image would feel like if

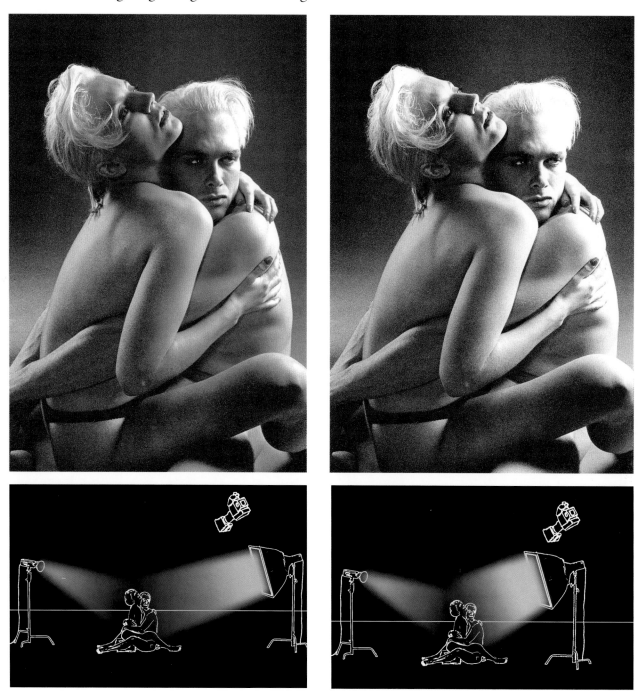

Frame 19 (left)—The main-light, a 2' x 3' Chimera softbox fitted with a White Lightning Ultra 1800 studio strobe light, was placed 8' away from the camera-right side of the subjects to create dramatic sidelighting. To reduce shadow contrast and separate the subjects from the dark gray wall, a non-diffused strobe head acted as both a separation and fill-light. It was fitted with a 7" reflector and placed 8' away from the camera-left side of the subjects.

Frame 20 (right)—The main-light was moved closer to the subjects, from 8' to 5'. The 1½ stop increase in brightness is not compensated for.

the shadows were much lighter. Would it convey the same mood? The next section will answer these questions and teach you how to create and control this type of shadow formation to accurately convey your impressions onto film.

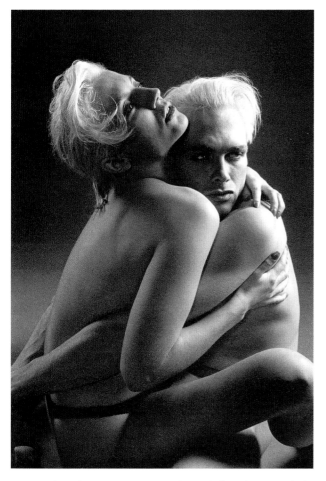

Frame 21—The exposure is adjusted for the main-light brightness increase on the subjects.

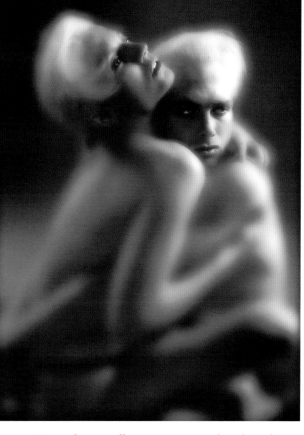

Frame 22—Softening effects were created in Photoshop.

FRAMES 19, 20, 21 AND 22:
Exposure: f4.5 at 1/60 seconds
Camera: Nikon 801 (35mm)
Lens: 35–105mm zoom set at approximately 80mm
Film: Kodak T-max 3200 rated at 2500 ISO (black & white)

It seems that all photographers feel they have a duty to do at least one nude sometime in their career. *Fallen Angels* filled that need for me. This dramatic image was done of two people from the alternate

side of life, who met earlier that day on the street. They quickly became infatuated with one another, due to their similar looks, and decided that they "had to have" a semi-nude photo session together.

This was a "go with the flow" type session, with creativity on the fly, so posing was kept to a minimum. The lighting setup was designed to give them as much freedom to move around as possible—keeping the lights further away created a larger area for them to work within where the exposure would stay consistent. For complete freedom and to follow the action, the camera was hand-held. To add some feel to the image, high speed black & white film was loaded into the camera. The film's high speed made using strobe light difficult, since the strobes were too powerful and could not be turned down far enough for a correct exposure relative to the desired aperture setting for depth of field. The strobe's modeling lights, which were very bright photoflood bulbs, were used in their stead. Once the lights were set up on the subjects, it became apparent that the shadows that were being filled in by the separation/fill light were too flat (low shadow contrast).

The lighting setup was designed to give them as much freedom to move around as possible . . .

■ SHADOW CONTRAST

Earlier, I stated that the definition of a shadow is an area that receives no illumination whatsoever from the main light. In lighting, we use shadow to help define an object's shape. Shadows do this by contrasting to the lit areas. Contrast, by definition, means to compare one thing to another. In lighting, everything is compared to the diffused value of the subject. So shadow contrast means shadow brightness relative to the diffused value brightness, or how much darker the shadow area is relative to the fully lit diffused value area. Notice the image *Fallen Angels*, Frame 19. On the main-lit side, the subject's diffused value is lit to its correct brightness on film. Contrasting to this lit side is the diffused value under-lit on the opposite side, the shadow side. Now look at Frame 21. What is the difference between Frame 19 and Frame 21? The shadow side in Frame 21 is darker than the shadow side in Frame 19. The Frame 21 shadow creates more contrast between diffused and shadow than does the Frame 19 shadow.

Which is best? That is up to you. How dark you make your shadows is totally your call (or your client's call). This is a creative/subjective area. Generally speaking, high shadow contrast (meaning darker shadows) creates a dramatic look. Low shadow contrast, meaning lighter shadows, creates a flatter look.

The five controls for shadow contrast are:

1. Distance of main light to subject
2. Main light distance (to subject) to ambient ratio
3. Efficiency of ambient source
4. Distance of ambient source to subject
5. Shutter speed (sometimes)

To increase shadow contrast for a more dramatic look on *Fallen Angels*, several options were considered before finding the best control for the job. On the separation/fill light, the modeling light had been turned down as far as possible, so its brightness could not be further reduced. Neither were any neutral density light gels available. The light could not be moved further away, nor could it be turned a little away from the subject (feathering) to reduce brightness because it was also lighting part of the background. It would have been necessary to rebuild the set and lose the moment with the subjects if it were not for a relatively unknown, wonderful control.

? Did You Know ?

We often talk about ambient light, meaning the existing light indoors or outdoors. It is often a concern when shooting on location—for instance, when photographing subjects in a room where you cannot shut off the lights, or cover the windows to block sky or sun light. When controlling shadow contrast in the studio, we also have to consider ambient sources. In this case, the term refers to light that has come out of the main light (or any other light source), spilled past the subject, hit a surface (such as a wall, a fill card reflector or a fill panel), then bounced back onto the subject. Its effect is most noticeable in shadow areas.

Sometimes you will find that a fill card reflector (or fill panel) cannot reflect enough light into the shadow. In cases such as these, shadow contrast can be reduced by filling in the shadow with an artificial ambient source (i.e. a strobe head, soft box, or umbrella).

Unwanted ambient light can be controlled with shutter speed, if you light your subject with strobe (flash) lights. This topic is covered in greater detail in the photo shoot called called "Simulated Sunlight" (page 60).

The brightness of the shadow can be controlled by changing the distance of the main light. If you move the main light closer to the subject, the shadows (which receive no light from the main light) will be unaffected (compare the shadows in Frames 19 and 20 from *Fallen Angels*). However, the subject's diffused value will receive more illumination from the main light. To maintain a correct exposure, it is necessary to re-meter for the brightness increase on the diffused value and adjust the camera's exposure setting accordingly. This new setting will correctly expose the diffused value, and devalue the shadow, underexposing it from what it was (see Frame 21). In the end, it appears as though the diffused value stayed the same and the shadow became darker. If the light were moved away from the subject, the opposite would occur. The diffused value would appear the same (after exposure adjustment for the loss of light), and the shadow would appear brighter.

Comparing the shadow brightness in Frames 19 and 20 of *Fallen Angels*, you may think there is a difference. The shadow in Frame 20 looks a little darker than the shadow in Frame 19. The two shadow densities are actually the same; they were carefully checked with a reflective meter. Why do they appear different? Contrast. Frame 20 has greater shadow contrast, which makes us perceive the shadow as darker. It is an illusion.

You may have noticed that the main light softbox had little effect on the background when it was moved in closer to the subjects. The main light was turned slightly away from the background (feathering) so that most of its energy fell upon the subjects and almost none fell on the background (which was a good 7' beyond the subjects).

Frame 22 of *Fallen Angels* was the complete version. This softening effect is selective. Notice that some areas remain relatively sharp, while other areas are soft. This effect can be created several ways:

1. A sheet of glass can be attached to a stand in front of the camera lens. While looking through the lens, smear Vaseline over select areas of the glass. Shoot with a fairly large aperture so that the Vaseline is quite out of focus. This type of softening flares the high lights. This effect was not a good solution for *Fallen Angels* because the camera was hand-held, and the subjects were constantly changing position.

In the end, it appears as though the diffused value stayed the same and the shadow became darker.

2. During printing, suspend a sheet of clear glass between the enlarger lens and the printing paper. To selectively soften, place pieces of clear plastic food wrap over different areas of the glass. Where you want the image sharp use no food wrap, where you want it soft, place the wrap and wrinkle or crinkle it. Changing the height of the glass controls how crisp or soft the effect is. Vaseline on this glass is another option. This type of softening flares the dark tones of the image. This darkroom method works well but is a long, painstaking task that requires a lot of trial and error—as well as patience and printing paper.

3. Thank God for computers! Image editing applications such as Adobe Photoshop have softening effects that can be applied to selected areas by several simple key strokes or painted in with a brush tool. This is the easiest method and offers the greatest amount of control. In Photoshop this type of softening can be made to flare just the highlights, or just the dark tones, or both depending on whether you choose lighten, darken, or normal mode in the layer window.

The next series of images *(The Humpty Dumpty Trilogy)* was created for an ad campaign for a prepress house, demonstrate some interesting controls over shadow contrast. The three Humpty Dumptys were constructed by a model-maker and had their faces painted on by an artist.

In Frame23, a White Lightning Ultra 1800 studio strobe light fitted with a 7" reflector acted as the main light. The reflector's frontal opening was covered with Tuff Frost diffusion material. The camera was set to f8 to correctly expose Humpty's diffused values lit by the main light. It was placed 1' from the camera left side of Humpty Dumpty.

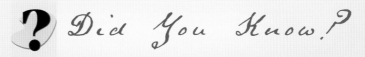
? Did You Know?

Quiz time! Now here's a question: will a pure black shadow on a white object have more, less, or the same shadow contrast than if the same shadow brightness were found on a dark gray object? More. The difference between white and black is far greater than between dark gray and black.

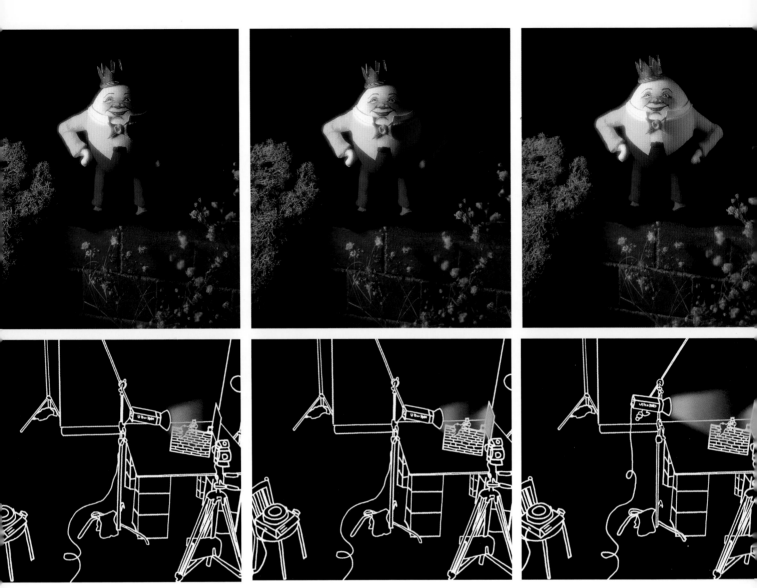

Frame 23 Frame 24 Frame 25

In Frame 24, a white card was positioned 1' away from Humpty, on the camera right side. It reflected some of the main light that was spilling past Humpty back onto the shadow side.

In Frame 25, to decrease shadow contrast, the main light distance was doubled to 2'. The power on the strobe main light was turned up by two f-stops to make up for the two stop light loss caused by doubling the main light's distance. If I had, instead, altered the f-stop to make up for the loss of light, depth of field would have been changed, altering the degree of sharpness I was after.

In Frame 26, to decrease shadow contrast further, the main light distance was doubled again, moved to 4' away. Once again, the power on the strobe main light was turned up to keep the exposure constant at f8.

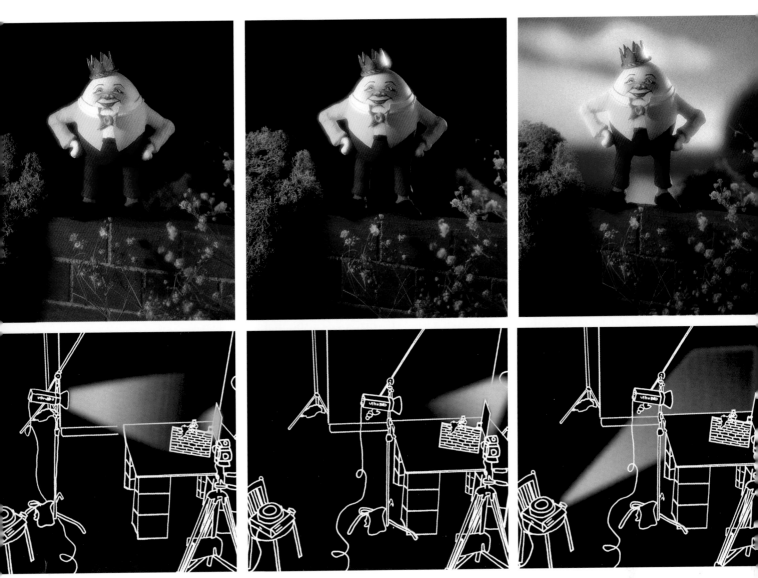

Frame 26 Frame 27 Frame 28

In Frame 27, preferring the shadow contrast of frame two, the main light was moved back to 2' and its power readjusted. To create separation from the background, another strobe light with a 7" reflector was placed 3' behind and to the camera right side of Humpty. It directed f5.6 (incident reading) amount of light onto the back edges of Humpty.

In Frame 28, to complete the nursery rhyme story, a slide image of a pond and trees were projected out of focus with a 35mm projector (with a blue color correction gel over its lens) onto a white seamless paper backdrop behind the set. The camera shutter speed was set to twenty seconds for a pleasing exposure of the background at f8.

Data for Frames

FRAMES 23, 24, 25, 27, 27 AND 28:
Exposure: f8 at 1/60 seconds
Filtration: Wratten 81A on front of lens
Camera: Hasselblad ELM
Lens: Hasselblad 150mm
Film: Kodak Ektachrome 100 Plus rated at 80 ISO

■ MAIN LIGHT DISTANCE (TO SUBJECT)

TO AMBIENT RATIO

Looking at Frame 24 of *Humpty Dumpty Sat On A Wall*, it's obvious that the shadow contrast is affected by doubling the distance of the main light from the subject. But why change the distance of the main light to alter shadow contrast when two other conventional controls (using a fill light or changing the distance of the ambient source—in this case a white fill card) are available? Last things first. I could not move the fill card in any closer or it would have appeared in the frame. As for using a fill light, as seen in the *Fallen Angels* image (pages 42-43), I would have run the risk of light spilling onto the white background and desaturating the backdrop projection.

Interestingly enough, changing the distance of the main light has the same end result in *Fallen Angels* as in *Humpty Dumpty Sat On A Wall*. However, it arrives there by a different principle. *Fallen Angels* had a stationary fill light, while *Humpty Dumpty Sat On A Wall* used a stationary white card as a fill light source. When the distance of the main light changed on the *Fallen Angels* image, the amount of light that the fill light projected onto the subjects' shadows was unaffected. When the distance of the main light changed on the *Humpty Dumpty Sat On A Wall* image, the amount of light that the fill card projected onto the subject's shadow was affected. Why is this so? Let's figure it out.

Shadow contrast is affected by ambient light sources (like a wall or a fill reflector) that reflect light from the main light into the shadow. Doubling the distance of the main light decreased the amount of energy lighting both sides of Humpty (less light hit him directly from the main light, and less light was bounced back onto his shadow side from the fill card). Both sides of Humpty got darker. However, the percentage of light lost on the main-lit side compared to the shadow side was not even. The main-lit side lost more of its original bright-

> *Shadow contrast is affected by ambient light sources that reflect light from the main light into the shadow.*

ness than did the fill-lit side. Since we could not leave Humpty's diffused values underexposed, the power of the main light was increased to make up for the light loss (I could have altered the aperture instead, but this would have totally changed the look I was getting with the f8 depth of field). Now the main-lit side was once again its original brightness and the shadow side was, believe it or not, brighter than before (less contrasty).

This effect occurs because of perspective. As the light moves away from the subject, the subject's main-lit side gets darker at a faster rate than does the shadow side. This happens because the light has to travel past the subject, strike the ambient light source's surface (in this case, the white fill card), then bounce back into the shadow. You may be saying, "Now wait a minute, earlier it was stated that a shadow is an area of the subject that receives no light from the main light source. Is not the shadow being lit from this same source?" To which I answer, no. The main light is not a source of illumination to the

Tech Tip

Separation lighting or backlighting really helps create the illusion of depth in an image by making the subject "pop-out" from the background. It becomes very important when dealing with dark tones where the subject starts to blend into the background, and in printing press situations that are less than optimum (such as newsprint). Unfortunately backlighting is difficult to meter accurately. The backlit areas are often too small to get an accurate spot reflective meter reading from, and since the backlight is beyond 90° from the camera, incident meter readings are incorrect. The best solution is to shoot a test consisting of a series of film frames with different separation light brightnesses in one stop increments. Measure the light with an incident meter placed against the back of the subject with its dome pointing at the backlight. Even though these readings are not accurate as to how the actual tone will record, they do provide a guideline. Label each frame of the tests with the difference in brightness between what the camera aperture is set at and with what the brightness is. For instance: two stops darker than the camera aperture is called a -2 incident, one stop is a -1, same as is a value zero, one stop brighter than is a +1, etc. If you are too lazy to do these tests, a really safe, all-purpose ratio can be achieved by setting the power on the backlight to read one stop less than what the camera aperture is set at. In other words, if the camera aperture were set at f8, then the separation light would read f5.6 incident (a minus one incident separation light).

shadow side, the white fill card is. However, since the main light is the origin of the source to the white fill card, then everything becomes interconnected. If you affect the main-lit side by altering the main light in some way, then to some degree the fill card will also be affected. This, in turn, will have an affect on the shadow side.

In Frame 23, the energy from the main light had to travel 1' to light Humpty's lit side, and 3' to his shadow side (2' to the white fill card that then had to reflect the energy an additional foot to his shadow side). Incident meter readings revealed that the light striking Humpty on his lit side read f8 and the light striking his shadow side read f2—the 3:1 distance ratio had made a four stop difference.

In Frame 24, the energy from the main light had to travel 2' to light Humpty's lit side, and 4' to his shadow side (3' to the white fill card that then had to reflect the energy an additional 1' to his shadow side). Incident meter readings revealed that the light striking Humpty on his lit side read f8 (once the power was adjusted to read so), and the light striking his shadow side read f4—the 2:1 distance ratio had made a two stop difference.

In Frame 25, the energy from the main light had to travel 4' to light Humpty's lit side, and 6' to his shadow side. Incident meter readings revealed that the light striking Humpty on his lit side read f8 (once the power was adjusted to read so), and the light striking his shadow side read f5.6—the 1.5:1 distance ratio had made a one stop difference.

To recap, when you move the light away, both the shadow side and the lit side become less bright. The main-lit side loses light at a faster rate than the shadow side. When the main light is positioned further away it is necessary to re-meter. However, this only ensures a constant exposure of the subject's main-lit side, not the shadow side. The shadow will appear brighter because it grew darker at a slower rate than the re-metered side. Behind this craziness is the law of perspective.

You may be thinking, isn't this what happened in *Fallen Angels?* Not exactly. In *Humpty Dumpty Sat On A Wall*, when the main light source changed distance, both the main-lit and shadow side were affected. In *Fallen Angels*, before readjusting exposure, only the main-lit side changed. This is for two reasons:

1. There was no significant surface (only dark gray walls) from which the main light spilling past the subjects could reflect back into subjects' shadows.

Behind this craziness is the law of perspective.

2. The lighting setup used in *Fallen Angels* employed a strobe head instead of a fill card as a fill light source to reduce shadow contrast. It produced light energy, while reflecting almost none of the stray light from the main light back into the shadows.

▥ IT'S THE LAW: THE LAW OF PERSPECTIVE

To understand distant relationships more clearly, try this exercise, place both your hands in front of your face. Put one hand at arm length and the other hand 6" in front of it. When you look at your two hands at this distance they look fairly close in size. Keeping the distance between the two hands constant, move them closer to your face. The hand that is closest to your eye grows at a faster rate than does the hand that is behind it. If you move them away, the closest hand shrinks at a faster rate than the further hand. That is perspective. Closer objects are affected at a faster rate than are more distant objects. Okay, you can put your hands down now.

Closer objects are affected at a faster rate than are more distant objects.

If you find yourself shooting in a small room with light colored walls you will find it difficult to create high shadow contrast, plus you will run the risk of color contamination in the shadows if the walls are not a neutral color. However, using the law of perspective to your advantage, you could work with the main light in closer to the subject. This ensures that the stray main light energy that is bouncing off the light colored walls back into the shadow will have much less affect on the shadow brightness and the shadow color balance.

▥ EFFICIENCY OF AMBIENT SOURCE

In this depiction of gratuitous violence (*Humpty Dumpty Had a Great Fall*), we see our once overconfident Humpty Dumpty splattered over the ground in what seems like a tough situation. The lighting however was not tough—it was easy because, for continuity, I used almost the same setup as in the last Humpty image. I did, however, use a different control for manipulating shadow contrast.

In Frame 29, Humpty was main-lit by a White Lightning strobe head with a 7" reflector with its frontal opening covered with Tuff Frost diffusion material. It was placed 2' from the camera left side of Humpty Dumpty. The camera was set to f8 to correctly expose Humpty's diffused values as lit by this main light.

In Frame 30, wanting to reduce the shadow contrast, a silver card (inexpensive foil board is available at graphic supply stores) was positioned 1' away from Humpty on the opposite side. It reflected some

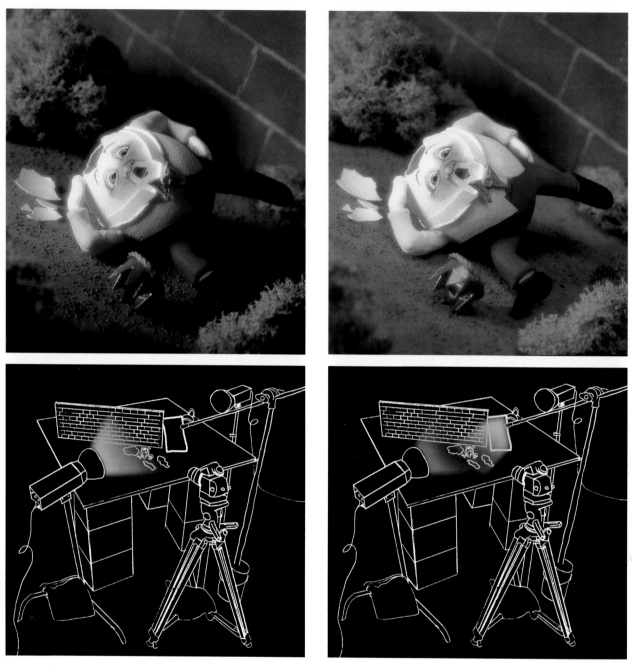

Frame 29

Frame 30

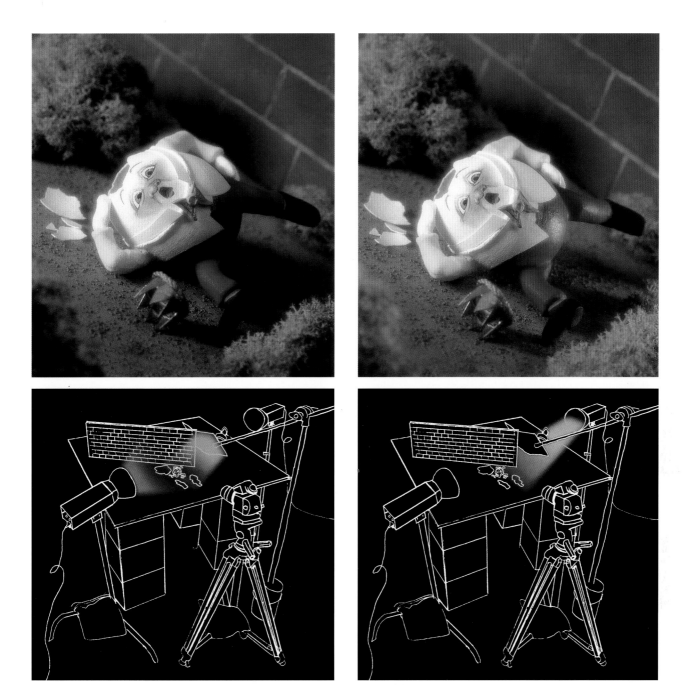

Frame 31 Frame 32

FRAMES 29, 30, 31 AND 32:

Exposure: f8 at 1/60 seconds

Filtration: Wratten 81A on front of lens

Camera: Hasselblad ELM

Lens: Hasselblad 150mm

Film: Kodak Ektachrome 100 Plus rated at 80 ISO

of the main light that was spilling past Humpty back onto his shadow side. An incident meter reading of the fill light read f5.6½—half a stop less light striking the shadow than striking the lit side.

In Frame 31, finding the shadow contrast too flat looking, the silver card was replaced with a less efficient source, a white card. An incident meter reading of the fill light read f4, two stops less light striking the shadow than striking the lit side.

In Frame 32, to create separation from the background, another strobe light with a 7" reflector was placed 3' behind and to the camera right side of Humpty. It directed light (f5.6 incident reading) onto the back edges of Humpty.

The tone of an ambient source affects how efficient that source is at reflecting light back into the shadow. Some tones are more efficient at reflecting light than others. The choice of the right surface is important when choosing a reflector for filling in shadows. A white surface is a more efficient reflector than is a black surface. A silver surface is an even more efficient ambient source.

However, as we saw in *Humpty Dumpty Had A Great Fall,* high ambient efficiency is not always desirable. For instance, creating dark shadows for dramatic lighting on a subject in a small room with light colored walls (which are very efficient reflectors of light), can be difficult. The spill from the main light bounces off the light colored walls and into the shadow creating low shadow contrast (light shadows). To prevent this unwanted ambient fill, you could (as we discussed earlier), work with the main light in closer, or you could place black material or black paper in front of the wall.

The same situation can happen in nature, too. Imagine trying to create a moody portrait with dark shadows on a sunny day outdoors in a location such as White Sands, New Mexico, where your subject is standing on miles of highly reflective white sand. Trying to block out enough of the light reflecting off the sand to create high shadow contrast would be a lot of work. In dealing with existing ambiance, it is generally easier to be in a situation where you need to add more

> Imagine trying to create a moody portrait when your subject is standing on miles of highly reflective white sand.

Tech Tip

Another way of controlling the fill intensity is to "feather" the main light a little bit off the subject and more onto the fill card. The main-lit side gets a little darker and the fill side gets a little brighter.

light (to decrease shadow contrast) than it is to block ambient light (to increase shadow contrast). That is why my brother and I painted our studio interior a dark neutral tone.

When photographing people outdoors in direct sunlight, large diffusion panels can be used to soften the hard light quality, as well as to reduce high shadow contrast. Sometimes the effect works too well—producing flat contrast (low shadow contrast). When the panel is dropped into place, the direct sunlight transmits through the translucent fabric stretched over the panel frame. This fabric absorbs some of the sunlight, reducing the amount of light striking the lit side of the subject. The shadow side of the subject is lit by the open sky and is unaffected by the fabric. Since the exposure has been reduced on the main-lit side by the fabric, it is necessary to increase the exposure to obtain a correct exposure. The increase in exposure, meant to correct the main-lit side, also lightens the shadow and decreases shadow contrast.

In the end, it appears as though the main-lit side stays the same brightness and that the shadow becomes brighter. To increase shadow contrast so that the lighting doesn't appear too flat, place a dark piece of material on the shadow side of the subject to block some of the light from the open sky. The dark material reflects less light back into the shadow than does the open sky, because it is a less efficient ambient source.

■ DISTANCE OF THE AMBIENT SOURCE TO SUBJECT

In the final image of the Humpty Dumpty trilogy (next page), we see our hero less than perfectly put "together again." However, we will not follow suit by dropping our own standards. Once again we will use our most excellent lighting setup, while exercising yet another shadow contrast control.

In Frame 33, Humpty is main-lit by a White Lightning Ultra 1800 studio strobe light fitted with a 7" reflector with its frontal opening covered with Tuff Frost diffusion material. It was placed 2' from the camera-left side of Humpty Dumpty. The camera was set to f8 to correctly expose Humpty's diffused values lit by this main light.

In Frame 34, wanting to reduce the shadow contrast, a white card was positioned 9" away from Humpty on the shadow side. It reflected some of the main light that was spilling past Humpty back onto his shadow side. An incident meter reading of the fill light read f5.6—one stop less light striking the shadow than striking the lit side.

Large
diffusion panels
can be used
to soften
the hard
light quality . . .

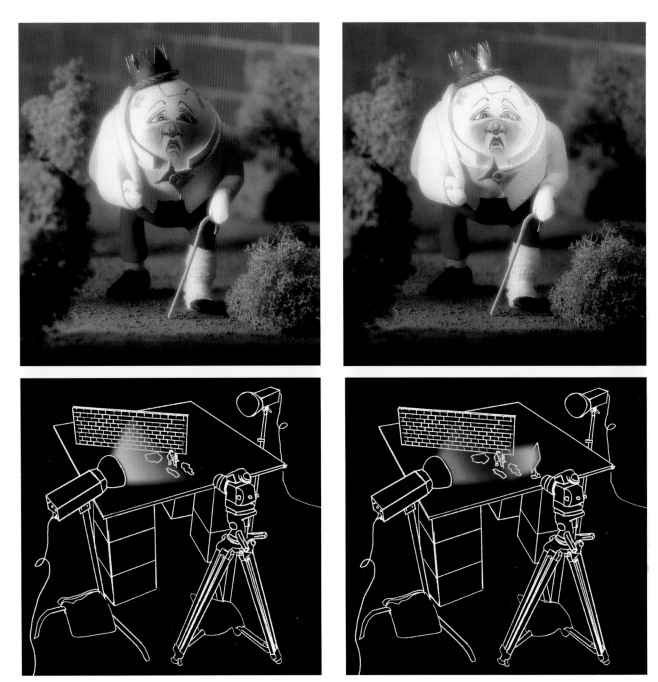

Frame 33

Frame 34

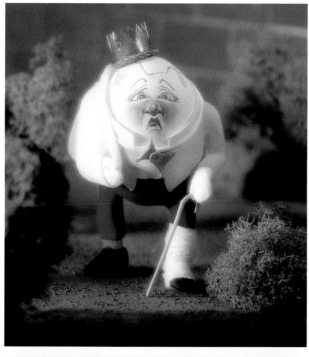

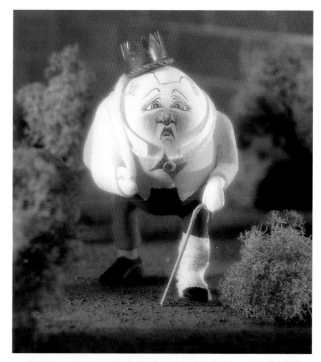

Frame 35

Frame 36

✔ *Data for Frames*

FRAMES 33, 34, 35 AND 36:

Exposure: f8 at 1/60 seconds

Filtration: Wratten 81A on front of lens

Camera: Hasselblad ELM

Lens: Hasselblad 150mm

Film: Kodak Ektachrome 100 Plus rated at 80 ISO

In Frame 35, finding the shadow contrast too low, the white fill card was moved from 9" to 12" away from Humpty. An incident meter reading of the fill light read f4, revealing two stops less light striking the shadow than striking the lit side.

In Frame 36, to create separation from the background, another strobe light with a 7" reflector was placed 3' behind and to the camera-right side of Humpty. It directed (f5.6 incident reading) light onto the back edges of Humpty.

The distance of the ambient light source to the subject is one of the most intuitive contrast controls. To decrease shadow contrast, move the ambient source closer to the subject's shadow side. This lightens the shadow by increasing the amount of light striking it. To increase shadow contrast, back the ambient source further away. The shadow will receive less light, making it appear darker.

▋ SIMULATED SUNLIGHT

What would you do if a client on a tight deadline needed a sunny outdoor image of their product, but the weather was not cooperating? Since my partner/brother and I own a commercial advertising photography business in a wet climate, this situation has become routine. One such project was a fashion shoot that required a light, airy, sunny look. Unfortunately it was needed during the wet season. Like most advertising projects, it had a tight time deadline, so waiting for the weather to break was not an option. Some pretty tricky trickery called "simulated sunlight" was the solution.

In Frame 37, models Michelle and Shelby were lit from overhead by a heavily overcast sky.

In Frame 38, a Metz CT 60 camera flash, held off camera and positioned behind the subjects, added bright rim lighting that mimicked the look of sunlight coming from behind.

FRAMES 37, 38, 39, 40 AND 41:
Exposure: f4 at 1/250 seconds
Filtration: Wratten 81D on front of lens
Camera: Hasselblad ELM
Lens: Hasselblad 150mm
Film: Kodak Ektachrome 400X Plus rated at 400 ISO

Frame 37

Frame 38

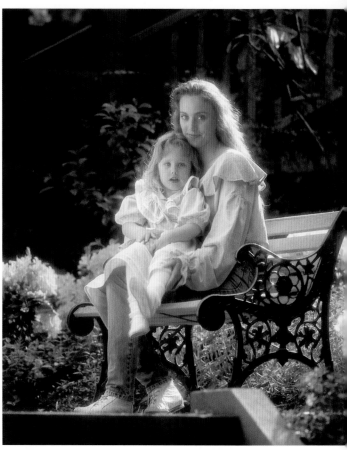

Frame 40

Frame 39

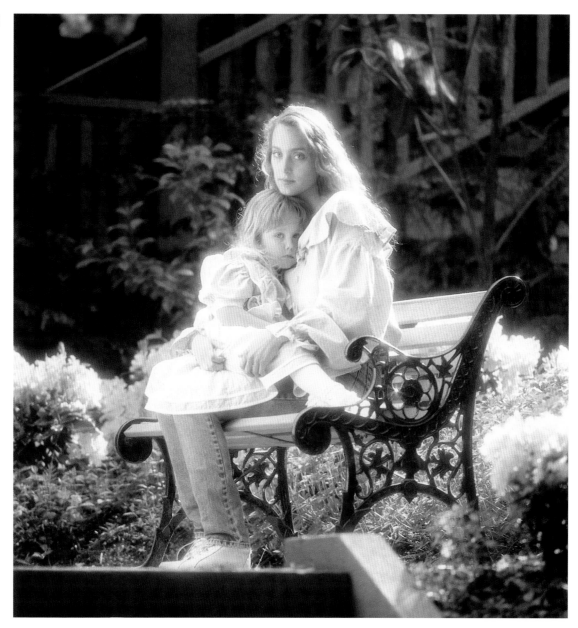

In Frame 39, a 6½' x 6½' PVC frame with white nylon stretched over it, placed to the camera left side of the subjects, reflected light from the off-camera flash back onto their fronts.

In Frame 40, a Wratten 81D warming filter was put over the front of the lens to warm up the color of the image. Typically, its filter factor (reduction of light) is subtracted from the light meter's ISO setting before starting the shoot. By altering shutter speed, the ambient light is underexposed by one to two f-stops.

In Frame 41, for a more light and airy feel, the entire image was overexposed by opening the camera aperture up from f5.6 to f4.

When using flash as a main light outdoors, shadow contrast can be controlled by altering the camera's shutter speed to control the

Camera flashes, of the more powerful variety that have manual power settings, make great inexpensive, portable, and self-contained light sources and origins. However, they need some way of being triggered when off-camera and at a distance. Radio slaves, which consist of a transmitter that plugs into your camera's PC outlet, and a receiver that the flash plugs into, are the best solution. Unfortunately, they are also the most expensive solution. 15' PC extension cords provide a much cheaper (but finicky) alternative. Up to three cords can be joined together to put the flash origin up to 45' away from the camera.

Some cameras and flashes do not have PC outlets, only hotshoes to trigger the flash. There are however adapters/attachments for both camera and flash hotshoes available at camera stores, that allow you to plug in PC cords.

This simulated sunlight technique does not always work out right on full-length shots. Often the subject seems placed in a puddle of light from the flash which ruins the sunlight illusion. However, a really low camera angle creates a totally believable look by compressing this large, brightly flashlit foreground/background area into a thin line under the subject. To get this low angle I set the camera 6" off the ground. Since I am so low down, I move far away from the subject so that the camera is not looking up at the subject on a severe angle. To make the subject fill the frame at this longer distance, I use a long lens or I crop in on the image afterwards.

Since camera flashes are not very powerful compared to ambient outdoor light from open sky, I generally find areas outdoors that have natural light blocks to gobo some the sky. It is important that the ratio between the flash and the ambient light is not too ridiculous. If so, it leads to extreme shutter speeds exceeding camera flash sync speed limits (usually 1/250 second on modern 35mm cameras). Moving under a tree or in amongst some buildings works well.

amount of ambient light from the overcast sky, thus creating a lighter or darker shadow. On overcast days (as in these images) or in shaded areas outdoors on sunny days, strobes can be used as main lights or as main light origins.

Capturing the burst of light from a strobe is more dependent upon aperture than shutter speed. This leaves the shutter speed free to control shadow contrast. This control is a "pop and drag" technique and a mixed lighting technique. The shutter opens, the strobe

fires (lighting the subjects' main-lit side), the shutter stays open burning the ambient light onto the subjects. By dialing the appropriate shutter speed, it is possible to dial in any shadow brightness.

For the image of Michelle and Shelby, f4 to f5.6 was required to create the desired depth of field. At f5.6 the ambient light read $\frac{1}{60}$ second. A f5.6 at $\frac{1}{60}$ second camera setting correctly exposed the subjects with open sky lighting. This was not what was wanted. Instead, wanting the open sky light as fill lighting, I set the shutter speed in frame three at $\frac{1}{125}$ second for a –1 fill (incident meter reading), and in frame five at $\frac{1}{250}$ second for a –2 fill. The faster the shutter, the higher the shadow contrast.

Obviously, ambient light strikes the main-lit side of the subjects as well as the shadow side. For a correct exposure of the subjects' diffused value on the main-lit side, this additional amount of light must be factored in. With a –1 fill, the main-lit side is receiving f5.6 amount of light from the main light, as well as f4 amount of light from the open sky. F4 is half as much light as f5.6. This means that the open sky will add half as much brightness onto the main-lit side. So, for a correct exposure, the aperture must be adjusted to 5.6 and a half. Dialing the shutter speed to one stop faster will create a –2 ambient fill. The correct exposure, then, would become f5.6$\frac{1}{4}$. However, a quarter of a stop difference in exposure cannot be detected by the human eye, so it is not worth being concerned about. Therefore it's okay to leave the camera aperture at f5.6.

This extra math can drive you nuts when you are in the midst of the shoot, so I ignore it. I am able to get away with this sloppiness because I am already doing a range of exposure "mood selections" by dialing the aperture in $\frac{1}{2}$ stop increments to give my client a choice of exposure "feels." Since I am usually trying to create a light and airy feel, both the client and I always pick an overexposed frame.

Most people seem to like overexposed Caucasian faces in fashion-style images—providing the image has been warmed (i.e. an 81D Wratten filter placed over the lens). Without the warming filter, people usually comment that the image looks washed out. This makes sense. If the image is overexposed, large areas of the face become white, making the flesh look washed out. The warming filter adds a little bit of density to these areas of no detail, making them acceptable to most palates.

Changing shutter speed and aperture got you mixed up? Set your flash or strobe lighting with your aperture, set your shadow brightness with your shutter speed relative to the preset aperture setting.

Obviously, ambient light strikes the main-lit side of the subjects as well as the shadow side.

This shutter speed mainly controls the ratio of lighting between the strobe and the ambient light.

For example, I take an incident meter reading of the main light (the white nylon material that is reflecting the rear strobe light onto the subject's front). I set my camera to this aperture (typically around f4 to f8 with 400 ISO film with the strobe positioned 8' to 16' behind the subject). I then take an incident meter reading of the ambient light. I turn the meter's shutter speed dial until I find the shutter speed that corresponds to the predetermined aperture. I underexpose the ambient light one to two stops by setting a shorter shutter speed. Then I start shooting.

▣ A SCARY THOUGHT

What would you do if you were asked to photograph an ice sculpture, or a hand-blown glass perfume bottle, or a glowing mug of beer, or a silverware setting, or a brushed steel appliance, or a black car with chrome details. Your heart beating a little faster? Don't feel bad, these requests will strike terror in the hearts of most photographers because these surfaces can be a nightmare—if you are not armed with the right knowledge.

In actuality, it is not so much a photographic problem as it is a lighting problem. Even if you have a fair knowledge of lighting with shadow you will be lost when shooting these subjects, since shadows cannot exist on their surfaces.

Unfortunately, most photo-education is not very strong on lighting. Typically it relies on methodology—lighting setups are taught but very little pertinent theory is covered. Have no fear, the images and text in the next section will "pump you up" with what you need.

These requests will strike terror in the hearts of most photographers . . .

Lighting With

Specular Energy

■ SPECULAR

Looking back at the billiard ball image (page 18), notice that sitting on top of the diffused value (the area where the diffused is correctly exposed by the main light) is an overexposed, distorted rectangle. This rectangle is called a specular. You may know it by one of its many subjective terms: sheen, shine, glare, wash-out, hot spot, catchlight, etc. A specular is a mirror image of a source of illumination seen on the surface of the subject; it is a reflection. If the specular is really bright, we can refer to it as a specular highlight. In the printing industry, they refer to very bright, burned-out speculars as catchlights or specular highlights.

A source of illumination doesn't have to be an actual light. As you will recall, the definition of "source of illumination" is: the last thing that light is transmitted through, reflected off, or emanated from to light a subject. A source of illumination could be a strobe, a diffusion panel, a soft box, a white wall, or a gray wall. It could even be a person standing next to your subject reflecting light from some other origin onto your subject. Hopefully that person is not you, standing beside your camera, wearing a crisp white shirt that shows up as a reflection on the subject's shiny surface ("Hi Mum!").

> A specular is a mirror image
>
> of a source of illumination
>
> seen on the surface of the subject

Speculars are focused energy as opposed to diffused energy. The light particles that light the billiard ball were emitted from a softbox and traveled in a straight line, as do light particles from any source. When these particles of light struck the red paint on the surface of the ball, some entered the paint's molecular structure by fitting in between the surface molecules, while others reflected or bounced off the subject by colliding

with the surface molecules (see page 15 for an illustration of this phenomenon). The particles that bounce back and do not enter the molecular structure at all are the particles of light that create speculars. The distorted reflection of the softbox on the surface of the ball is a specular.

Since the billiard ball has a smooth, shiny surface, the light particles bounce off parallel to one another. They bounce off the surface at exactly the same angle at which they hit it, but in the opposite direction. For instance, if you were to point a light on a 45° angle at a given point of the ball's shiny surface, the striking particles would hit that surface on a 45° angle and would bounce off on a 45° angle in the opposite direction (Diagram 7). The angle of incidence equals the angle of reflectance. Incident means to strike, reflect means to bounce off. The angle from which the light strikes is the same angle that the light bounces off that surface, only in the opposite direction. This is true unless, of course, the light strikes the surface on a 0° angle, in which case the energy will bounce off that surface and come straight back the way it came.

Since the billiard ball has a smooth, shiny surface, the light particles bounce off parallel to one another.

angle of incidence

90° **45°** **45°**

angle of reflectance

Diagram 7

If the surface of the subject was matte or rough, then (on a greatly magnified level) the surface would appear like that of the moon; pitted with craters making many different angles. When particles of light strike a rough surface they cannot bounce off parallel to one another because each particle is hitting a portion of the surface that is on a slightly different angle than the other portions. The rougher

the surface, the more the specular will begin to break up and spread out. If you look at a shiny surface on a greatly magnified level, the opposite is true, the surface appears smooth.

A smooth surface appears "two dimensional" and a rough surface appears "three dimensional." A broken up specular (as seen on Leslie Nielsen's chest on the *Lord of the Violin* image in Frame 1 on page 14) is still a specular, but it is a degraded reflection instead of a concise reflection of the source of illumination. Speculars are subjective; they can be created to appear at any brightness lighter than the diffused value of the subject. As photographers, we use them to create shape and form on shiny and/or darker objects. Speculars also identify surface quality, telling us how shiny or how dull a surface is. When lighting with speculars, we must consider and control the specular's edge transfer (called the specular edge transfer) as well as its brightness (called the specular contrast).

SHOOTING BEER/PAINTING WITH LIGHT

The liquor business is a lucrative industry. In fact, it is one of the few industries that seems to grow even when the economy is down. It makes good business sense to round out your client roster with at least a couple of breweries.

To shoot advertising images for breweries, there are a few things that you need to know: bottles and mugs are usually made of glass; most beer must glow; beer is cold (in North America at least). There's nothing like stating the obvious—however knowing these facts is an important part of the process of figuring out how to tackle the shot. Since the subjects are partially glass, lighting will involve creating and controlling speculars. Since liquids are involved, glows must be created. Since the liquid is supposed to appear cold, sweat has to be created on the glass surfaces. Since this sweat is a liquid, the labels on the bottles must be waterproofed to prevent soaking through. We'll examine the process in a series of images entitled *Shoot*

Out at OK Spring, a play on the old west legend "Shoot Out At the OK Corral."

The five bottles of Okanagan Spring beer were placed on a rustic wood box that simulated an old west corral railing. To convey the dramatic feel that the client wanted, a 4 x 5 camera was positioned in close (1.5' from the subjects) and on a low angle. The low angle created a distorted perspective, so a 90mm wide-angle lens was used to fill the frame appropriately. For a dramatic effect, conventional lighting and painting with light were both used.

On *Shoot Out At OK Spring*, painting with light allowed the beer labels to be lit without any of that light affecting the old wood surface. The wood surface was side-lit by the two separation light 3'x4' softboxes. These lights accentuated the wood's texture, and created dramatic dark shadows. Main-lighting with a softbox would have created a "flatter" look, killing the dramatic feel. Spot lights could have been a solution, but nasty little "hotspots" (bright unwanted specu-

> For a dramatic effect, conventional lighting and painting with light were both used.

 ✔ *Data for Frames*

FRAMES 42, 43, 44, 45, 46 AND 47:
Exposure: f16 (at bulb setting)
Exposure procedure:
1. Room lights turned off
2. Shutter opens, paint main label of one bottle, shutter closes
3. Shutter opens, paint neck label of one bottle, shutter closes
4. Repeat steps 2 and 3 for the four remaining bottles.
5. Shutter opens, softbox strobes are fired, shutter closes. During all the subject exposures, a 4' x 5' black cloth was suspended 3' behind the subjects to block spilled light from the softboxes from desaturating the background storm effect.
6. Shutter opens, paint rear of bottle for glow, shutter closes
7. Repeat step six for the four remaining bottles
8. Remove black cloth to reveal background, shutter opens, background strobe is fired, shutter closes.

Filtration: Wratten 81A and softening created by a double layer of black tulle netting over the back of the lens
Camera: Sinar P2 4 x 5 view camera
Lens: Rodenstock 90mm
Film: Kodak Extachrome 100 Plus rated at 80 ISO (4 x 5 sheet film)

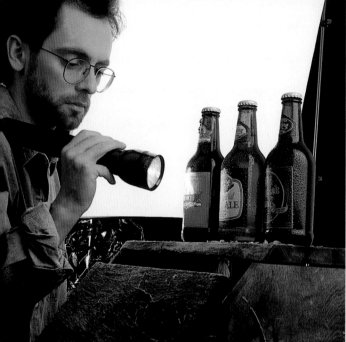

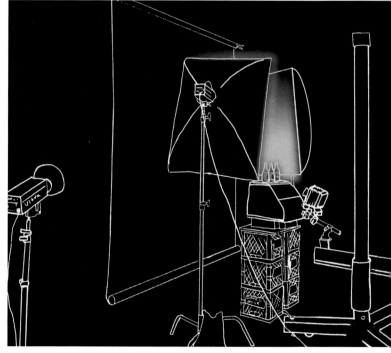

Frame 42—A daylight balanced three "D-cell" size Mag-Lite® flashlight fitted with a 3200°K to 5500°K correction gel (blue in color), painted light onto the labels.

Frame 43—To create wrap-around speculars on the subjects' sides, as well as light the old wood surface and add "fill-light" to the labels, two 3' x 4' Chimera soft boxes fitted with Whitelightning Ultra 1800 studio strobes were placed barely out of camera frame, on either side of the set.

Frame 44—bottle glows were created by moving the flashlight up and down behind each of the bottles.

Frame 45—A Whitelightning Ultra 1800 studio strobe, fitted with a 7" reflector, projected light onto a white seamless backdrop paper behind the set.

Frame 47—The same image as Frame 46 except the front bottle label has been sprayed with gloss lacquer rather than a matte lacquer.

Frame 46—To simulate a dramatic stormy sky, soft-edged shadows were created on the seamless backdrop by blocking some of the background light with tree leaves. An amber gel (Roscolux Bastard Amber #02) was placed over the front of the background light to warm the color balance of the background.

lar highlights) would have occurred on the glass of the bottles. Instead, a Mag-Lite® flashlight held about 2" away from the beer labels was used as a light painting tool. The flashlight was moved around, painting light over the labels for several seconds to build up the exposure. With the Mag-Lite® color corrected to the daylight transparency film, the large labels were "painted" for approximately twenty seconds each, the smaller neck labels, four seconds each.

Both separation softboxes read f11, one stop (−1 incident) below the camera's f16 aperture setting. The incident meter readings for the boxes were taken at the bottles. The meter's dome was pointed at the softboxes.

The bottle glow exposures were calculated with an in-camera reflective spot metering probe. The exposure readings varied from f16 at two seconds to f16 at eight seconds. The different "thickness" of the types of beer caused the variance. These readings were multiplied by the area that the light source needed to cover.

When painting the beer labels, the light painting tool was held to the side of the label. The light was rotated in small circles while it was moved horizontally across the label. Since the labels were on vertical cylinders (the bottles), a bright and relatively hard-edged specular highlight appeared down the very front of the labels. In this instance, the labels were water-proofed with matte print spray. The rough surface from the matte spray broke up the specular highlights, making them less bright and very soft edged. However, if the client did not want this rich low intensity soft-edged "sheen" across the labels (which also desaturated the labels color somewhat) another painting angle and movement could have been used. By painting vertically instead of horizontally, these speculars could easily have been hidden, even on a glossy label. To do this, a gobo needs to be attached to the light painting tool. A piece of black foil or black paper wrapped around the business end of the flashlight creates a cone called a snoot. The opening on the end of the snoot is cut diagonally as opposed to straight across. Vertical painting from the top down or bottom up then allows the black foil or paper snoot to act as a gobo, blocking the specular from the camera's view during the light painting exposure.

Black tulle was also placed over the back of the lens inside the 4 x 5 camera. This slightly softens the image, adding a little magic without drawing attention to the effect.

By painting vertically instead of horizontally, these speculars could easily have been hidden . . .

An Elegant Aside

Black tulle is a black netting material that is used in fashion for veils on women's hats. A lifetime supply is available at fabric stores for next to nothing. Or, if you are an adventurous soul, try standing quietly at the back of a funeral with a good sharp pair of scissors to snag yards of the stuff.

Two layers placed over the lens (or behind the lens on a view camera) create a magical softening effect that is quite subtle. This technique is aperture sensitive: a larger aperture opening renders a softer look; a smaller aperture opening renders less softening. Be careful when stopping down to an aperture opening smaller than f8 (such as f11 or f16). The increase in depth of field starts to bring the netting in focus, making it look as though you are shooting through a screen door.

If you place the netting over the back of the lens on a 4 x 5 view camera fitted with a telephoto lens, aperture settings up to f22 are safe. The longer the view camera's bellows extension, the softer the effect. Using tulle on the back of a wide-angle lens at even f22 will start to give the "screen door effect." This is because the bellows extension on wide angle is always short compared to telephoto. When the back of the lens is closer to the film plane, filters on the back of the lens come more into focus.

Case in point: notice on frame three of *Shoot Out At OK Spring* how the black cloth has a mottled blotchy look. This is from the tulle "softening filter" being too much in focus. Since the background in the final image was to be mottled, the dark blotches caused by the netting added to the effect, making them a benefit rather than a problem. On a plain background, these blotches would have been unacceptable. If you run into this problem, there are two solutions: sacrifice some depth of field by shooting at a larger aperture (opening to throw the netting further out of focus), or switch to another type of softening filter that is affected less by aperture. An acetate sleeve would be a good choice, however, acetate softening is a different type of softening and will not look quite the same as softening with tulle.

Keep in mind that any filter placed over or behind the lens will absorb some light. This "filter factor" needs to be accounted for otherwise your images will be underexposed. The black tulle that I use when doubled over absorbs 4/10 stop of light. Black silk pantihose (single layer) work much the same, but have a more pronounced effect and have a filter factor of around −2/3 stop.

▓ LIGHT PAINTING 101

Painting with light is a wonderful way of lighting selectively. The look is a rich, mottled lighting effect that can easily accent select areas without affecting nearby objects. It creates soft transfer edges, with a gradation of exposure over a given diffused value.

Light painting involves holding a small light source in very close to the area that you want to light, then moving it around that area for several seconds building up the exposure (see Frame 42, page 71). Light painting exposures are generally four to sixteen seconds in duration. An image is often made up of many of these exposures, so it is important to work in a reasonably dark room.

Recipe for Perfect Beer Images

Bottle:

First, soak off the labels, then use ammonia to clean off the glue residue. Finish by polishing with car wax.

Label Preparation:

First, water-proof the labels by spraying them with photographic matte or gloss lacquer. To spray a label, place it on a small piece of paper. Do not spray directly with spray can; start spray away from label and lightly "dust" spray over its surface. After a couple of passes dry the label with the blow-dryer. To prevent the blow-dryer from blowing the label away, place the dryer directly over the top of the label. Turn on the blow-dryer, and don't move it around. Next, turn the paper over. Place the dry, sprayed side of the label face down on paper. Repeat spraying label procedure. Always spray in a well ventilated space, while wearing a mask and goggles.

Applying Labels:

First, take a water-proofed label and stick a length of double sided adhesive tape down the back right side, the back left side, and a very short length on the back top center. The tape should be very close to the edge of the label and run to the top and bottom edge. A Scotch Brand® ATG 751 tape gun with #924 Scotch Brand® adhesive tape (thinner than regular double sided tape) works very well. With the tape applied, hold the label over the bottle. Visually align and center using a reference bottle (with a factory applied label still on). Lightly tack down the top center of label. View to see if it sits straight on bottle, adjust accordingly. When the label is set correctly, with two fingers rub the label in an up/down motion starting at its center working towards the left edge, then from center to the right edge. This will stick it to the bottle without wrinkling. Apply the top label the same way as the main label. This procedure is good for applying any label to any cylinder.

Sweating Bottle:

Begin with with an empty spritzer bottle, such as a manual pump hair spray spritzer, for a really fine spray. Fill with 50% water and 50% glycerin or corn syrup (I prefer corn syrup). If the client wants the bottle neck sweat free, hold a sheet of rolled paper over the neck of the bottle to prevent spray from falling on it. Spray a fine mist over the label and bottle. Spray from a slightly high angle to prevent droplets from getting under paper tube and landing where they shouldn't. To create heavier sweat, continue to spray a fine mist. Droplets will bunch up together to make big droplets. If droplets get too big, they will run. If they start to run (or look big and threatening), lightly dab these dangerous drops with a cotton swab.

Despite these longer exposure times there is little to no reciprocity failure. Since the light source is constantly moving, no one area is being exposed for the full time. Any change in exposure from reciprocity failure is hardly noticeable, since these areas are unevenly exposed, gradating gradually from slightly under, to right on, to

slightly over. If you are really picky, tables for calculating exposure and color correction for reciprocity failure are available from the manufacturers of your film.

When painting, the light source is in so close to the subject that your hand and arm are often in the shot. These do show up on film because the amount of light that reflects off them is of such low intensity (compared to the light coming off the area being lit) that it does not register. However, wearing a white or highly reflective top might be pushing it. The same is true of the bit of light that bounces around from the light painting source and hits other areas of the shot that you do not want lit. Something that can show up is the actual "business end" of the light painting tool if you allow it to point even a little bit towards the camera. It can produce weird ghosting streaks in your image, so keep the light pointed at the subject and away from the camera lens.

Manufactured light painting systems available at camera stores are easier to use and are much more sophisticated than a flashlights, but they are a little pricey for someone who is only occasionally doing light painting. Since creating *Shoot Out at OK Spring* I have found a better light painting tool than the Mag-Lite®. Inexpensive quartz halogen bicycle lights are smaller and much more powerful than flashlights, making them much easier to handle. They are also pretty close to 3200°K, which is easy to correct to 5500°K daylight with a correction gel or filter taped over the front. They also come with a rechargeable battery pack that you can clip to your belt. To shape the light beam of the tool, "black wrap" (looks like a black aluminum foil) or black paper can be affixed with black tape to the light, creating a "snoot" (an extended tube or funnel) on the end of the light.

One decent solution is to hold the light painting tool directly over the white dome or disc of an incident meter.

Figuring out exposure can be a little tricky. One decent solution is to hold the light painting tool directly over the white dome or disc of an incident meter. The distance that it should be held above the meter should roughly equal the distance that it will be held from the subject when light painting. In the case of the beer labels, approximately 2". The resulting reading needs to be multiplied by the area that will be painted over. In the case of the beer labels, four times. Since the light is in motion its energy is being spread around making any given point of the subject less bright than if the light were held still on that point for the duration of the exposure. This solution is very rough; I typically find that the exposure needs to be increased from this reading by two thirds to one full stop. It makes sense to shoot a test Polaroid to be sure.

Before actually exposing any film or Polaroid, it is a good idea to do a dry run. This dry run helps you to figure out the best angle to paint from and to see where unwanted speculars from the light painting tool might appear. To get rid of the unwanted speculars, place your head in front of the camera lens so that you see from the same angle that the camera views the subject from, or have someone look through the camera and direct you. By trial and error you will soon find what angles to hold the light at to get rid of them.

To avoid abrupt tonal irregularities on your subject when painting with light, make sure that you start the movement of the light source before the camera opens, and that the movement continues for a short time after the camera shutter closes.

When light painting it is really helpful to hear the individual seconds go by so you can gauge how quickly the light source needs move over the target area. Use a metronome or a darkroom timer with an audio feature for accurate timing. If neither of these are available, a tape recording of your voice calling off the seconds works well.

Make sure that you start the movement of the light source before the camera opens . . .

SPECULAR EDGE TRANSFER

Specular edge transfer is the area where the specular transfers into the diffused value. It may be a very sharp distinct area, such as seen on a very concise reflection. On the other hand, the edge of the specular may transfer over a much larger area creating a soft gradation from the specular into the diffused value (subject's true tonality). With a soft edge transfer, a specular (a reflection) appears out of focus on the surface of the subject. The six controls for specular edge transfer are:

1. Surface efficiency
2. Camera f-stop
3. Incident distance
4. Reflective distance
5. Motion of source
6. Distance of origin to diffusion source

SURFACE EFFICIENCY

Surface quality affects specular edge transfer. A smooth surface is more efficient at reflecting light than is a rough surface. A smooth surface on a magnified level appears two dimensional when compared to the three dimensional look of a rough surface. When light from a given source strikes a smooth surface, the particles of light bounce off parallel to one another creating a concise reflection of that light

source. If the surface is rough, the particles hit a multi-angled surface. Since each particle hits a different angle, it bounces off in a different direction. This diffuses the specular, making it appear out of focus (the specular's edge gradates over a larger area).

Automobiles roll out of the factory with shiny finishes. They have very smooth surfaces, so we see concise speculars on them. The edges of the speculars on the car's finish are hard; they are very sharp and in focus, and they gradate over a really small area. As the paint finish ages, it becomes pitted, oxidized, and the surface becomes rougher. No longer do you see those concise specular edges, because the rough surface breaks them up and makes them soft edged.

Specular edge transfer is also indicative of wetness. If you look outside to see if it has rained, what do you look for? You subconsciously look to see how "shiny" various surfaces have become. You might look at the asphalt surface of a road. The transfer quality of the speculars on the blacktop identify surface structure and reveal whether the road is wet or not. On a dry day, the road surface is very rough, so it breaks up the speculars, and they mix in with the black asphalt creating a gray tone. Once the surface becomes wet, a very thin layer of water sits on top of the asphalt surface. The water's smooth surface creates a more efficient reflector than the blacktop's rough surface. You see fairly concise reflections on the road—the road takes on a shiny appearance. The speculars are no longer blended into the asphalt, and where there are no reflections you see the asphalt's black tone showing through.

In Frame 46 (*Shoot Out at OK Spring*) the beer labels are spray lacquered with matte print spray. The matte spray reticulates the surface creating a less efficient reflector, softening the specular edges and making the speculars on the labels less distracting (and to my eye, more pleasing). If you compare frame five with frame six (which has the bottle label coated with gloss lacquer), the difference is dramatic. The gloss label breaks up the specular less, creating a hard specular edge transfer. Because the specular is less spread out, it appears much more intense.

> If you look
> outside
> to see if
> it has rained,
> what do you
> look for?

Quick Reference

Specular Edge Transfer: The area where the specular (reflection of the source of illumination) transfers into the diffused values of the subject.

DEPTH OF FIELD

Depth of field affects specular resolution (how in focus the specular appears). A reflection on a surface may be out of focus even though the surface is in focus. The surface may be within the camera's depth of field but the reflection of the light source may be beyond the depth of field's sharp range (even though the specular appears on the subject's surface). A reflection has a "visual depth"—depth within the surface of the subject.

Aperture creates depth of field. Depth of field extends approximately one third in front of the subject surface and approximately two thirds behind or into the surface of the subject. If, for instance, a light source was placed 12" away from a shiny surface, and if the camera aperture created a depth of field that extended 6" in front of the subject and 12" into the surface of the subject, the resulting specular on that surface would be in focus. In fact the light could be moved to any distance between 0" and 12" and still be in focus. However, if the light was 13" away or greater, it would begin to appear out of focus, spreading the edge of the specular over a larger area.

The three controls that govern whether the light source is within the depth of field of the camera aperture are as follows:

1. Camera f-stop
2. Incident distance
3. Reflective distance

FLOATING SONYS™

When the client saw Frame 48, she liked the specular along the edge of the radio. She thought it made the inexpensive radio look more pricey. She asked for more of that "sheen" on the top surface and asked if it could be more "liquidy."

Clients and art directors are always throwing subjective jargon at photographers. It is easy to become frustrated trying to interpret what they really want, but they are not to be faulted. We photographers are supposed to be the lighting experts, and we are the ones who need to be intimate with the vocabulary and underlying foundation of creating with light. For this reason it is our job to patiently extract from their flowery explanations what it is that they want, then deliver it.

So what did she mean by "liquidy sheen?" "Liquidy sheen" is simply low to medium specular contrast with a soft specular edge

Frame 48—For a main light, a 4' x 6' Chimera softbox fitted with a Speedotron 4800 strobe head, was placed three feet away from the two radios. This light source was also the primary source of illumination for the background.

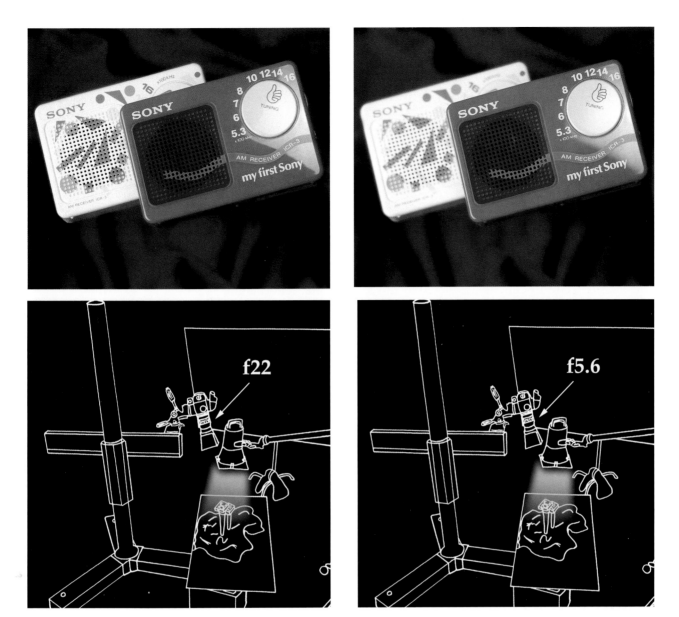

Frame 49—At the client's request, a second specular was created on the top surface of the near subject by positioning a diffused Speedotron 2400 strobe head accent light above the top radio. Strobe distance: 12". Camera aperture: f22.

Frame 50—to soften the edge transfer of the specular on the top of the near radio, the camera aperture was enlarged. Strobe distance: 12". Camera aperture: f5.6.

transfer. That is to say, the specular's brightness gradates from its brightest point gradually into the diffused value. To create the effect that she was after, there were four possible controls to consider:

1. Camera f-stop
2. Incident distance
3. Reflective distance
4. Motion of source

Each had its merits, and each had its trade-offs. The challenge was finding the control with the least compromise.

Numerous "hot spots" on the surface of the near radio (from the bare strobe tube and the 7" parabolic reflector) were subdued by taping a frosted acetate gel over the business end of the strobe head. To transform the circular dimension of the strobe head, a rectangular frame was cut from a piece of firm black card. With this placed over the top of the frosted acetate gel on the strobe head, the shape of the specular highlight from the strobe head on the surface of the top radio appeared rectangular. In essence, the round bare strobe head was turned into a 4" x 6" mini softbox. With the camera aperture set at f22, much depth of field was created. The specular from this mini softbox (as seen in Frame 49) was within this sharp zone, rendering it in focus. This created a hard specular edge transfer; an edge that had to be softened somehow.

In essence, the round bare strobe head was turned into a 4" x 6" mini softbox.

■ CAMERA F-STOP

Altering the camera's aperture was the first control used in an attempt to soften the specular's edge. In Frame 50 we see the result of reducing the depth of field (f22 aperture enlarged to f5.6) to keep the strobe head out of the sharp zone. This control worked very well at keeping the reflection of the strobe head out of focus. Shooting at f5.6 at this distance created a very shallow depth of field—so shallow that the second radio became quite out of focus. Since the second radio was a subject and not a prop or background, it was necessary to dial the camera aperture back to f22 and try a different specular edge transfer control that would create a soft transfer edge while keeping the second radio somewhat sharp.

If shallow depth of field did not cut it then perhaps pulling the light source out of the sharp zone would. In other words, alter the incident distance.

✔ *Data for Frames*

FRAMES 48, 49, 50, 51 AND 52:
Exposure: f22 at 1/60 second and 4 seconds
Filtration: Wratten 81A filter
Camera: Hasselblad ELM
Lens: Hasselblad 150mm
Film: Kodak Extachrome 100 Plus rated at 80 ISO

Frame 51—A soft specular edge transfer is created using a different control. The strobe head is moved further away from the surface of the near radio. The strobe distance is 36" and the camera aperture is f22.

Frame 52—A soft specular edge transfer is created yet another way. The strobe head is positioned 12" away from the radio surface. The strobe is turned off and so are the room lights. The strobe's modeling light is turned on. The strobe head is filtered with 3200°K to 5500°K conversion gel. It was shaken/rotated over a 4 second exposure at f22.

▪ INCIDENT DISTANCE

Incident distance refers to the distance of the light source to the subject. The accent light's close proximity to the radios made the edge transfer from specular into diffused cover less area. To increase this area, the accent light was backed away from the subjects, placing it beyond the depth of field created by the camera's f22 aperture. As a result the radios were rendered sharp and the specular edge transfer

soft, as seen in Frame 51. A close incident distance makes specular edges harder; a far incident distance makes specular edges softer.

REFLECTIVE DISTANCE

Another control that can be used to soften specular edge transfer is reflective distance. Reflective distance refers to camera distance from subject. Moving the camera close to the subject makes the specular edge transfers look softer; moving the camera away makes the edge transfers appear harder. Altering the distance of the camera to the subject will also change reproduction size (the size of the object on film relative to its actual size [see "Reproduction Size and Wrinkles" below]). Reproduction size affects depth of field, so changing camera distance alters specular edge transfer.

Moving the camera in closer to the radios does begin to throw the specular (caused by the accent light) out of focus. However, for this shoot, the control creates an undesirable affect, since moving the camera closer to the subjects crops into the scene too much.

REPRODUCTION SIZE AND WRINKLES

Why does changing camera distance or your viewing distance affect depth of field? Anytime you alter camera distance, you also alter reproduction size. If the camera is in close, reproduction size is increased. If moved away, the reproduction size decreases. Reproduction size is the relationship between the actual size of the subject relative to the subject's size on film (actual size to image size). This reproduction size affects depth of field.

> Moving the camera close to the subject makes the specular edge transfers look softer . . .

For instance, the background in an image of a person photographed full length would appear more in focus than the background in a headshot of the same person shot at the same aperture. The full length image would reduce a 6' high human subject to approximately a 1" image size on 35mm film. A headshot of the same subject would reduce a 1' high head to a 1" image size. The actual size of the person is reduced less. With less reduction comes less depth of field, with greater reduction comes more depth of field.

Stopping down the aperture is the most common control for depth of field increase. This works well, but after a certain point, stopping down compromises image quality due to light diffraction (f45 and beyond for 4 x 5 format).

Reflective distance is a less common, but equally powerful, control when photographing objects where a lot of depth of field is required. Instead of stopping down, back the 4 x 5 camera away from the subject, reducing the image size in the camera to gain more depth of field. The trade off is more grain—but it's usually not enough to matter on such a large format. As depth of field increases by moving the camera away, so does specular resolution. The specular comes more in focus because of the image size reduction. The object's size is smaller on film, so the depth of field increases, causing the specular to be within (or closer to) the depth of field sharp zone.

After a certain point, stopping down compromises image quality due to light defraction.

? Did You Know?

Why do we use the word "reflective" in the control called "reflective distance?" Photography can be broken down into two sciences, reflective and incident. Reflective refers to everything you do to affect the image after the light has bounced off or emitted from your subject. This would include decisions about: exposure, camera distance and angle, camera filters, film, digital backs, ISO, aperture, shutter speed, camera format, view-camera movements, lens, developing time, processing chemistry, darkroom techniques, traditional retouching, electronic retouching and manipulation, etc. Incident refers to everything you do to affect light quality before the light strikes the image. This would include decisions about: light gels, lights (available, tungsten, HMI, strobe, etc.), size and distance of light sources, diffusion materials, light dispersion, light feathering techniques, gobos, etc. So, reflective distance refers to receiving distance, which may be your eyes or may be your camera.

Imperfections in a light source (e.g. wrinkles in the panel) can show up in the specular if the source is in or near the sharp zone. However, keeping the source in the sharp zone is a great way to produce effects such as a product logo imaged inside a specular. This effect can be created by putting the logo over a large light source (a softbox or scrim). The logo can be reproduced on a large piece of lithographic film or can be printed on a large sheet of clear acetate by a laser printer. This reproduction of the logo is laid over the light source so that it reads backwards. The logo, like the light source, will be seen on the surface of the subject as a reflection. The logo will image the right way around in all the speculars on that subject caused by that light source.

When the client saw Frame 51 of the radios image (page 83), she liked the softer specular edge transfer on the top radio's specular. However, she wanted it softer still. Moving the light further away to throw the specular edge more out of focus started to create complications. For instance, when moved too far away, some of the camera/lighting rigging was in its way. Also, the further away the accent light was moved the smaller the specular became on the top radio's surface. It made sense to look for alternate solutions.

A decision (and a very sly one at that) was arrived at. The accent light was moved back to the original 12" distance. A 3200°K to 5500°K conversion gel was placed underneath the diffusion material over the accent light's front. The light's strobe tube was turned off but its modeling light was left on. The camera's shutter speed was set to "B" for bulb, to allow a four second exposure.

The procedure went like this. In a darkened room, the accent light was shaken, wiggled, and jiggled (making it cover a two to four times larger area). The camera shutter opened and the strobe fired. The shutter stayed open for a full four seconds burning in the daylight-corrected blurry reflection of the accent light on the surface of the top radio. When the shutter was closed, the motion of the light was stopped. This technique is called motion of source.

■ MOTION OF SOURCE

Motion is yet another way to throw a specular highlight out of focus. Shaking or moving a source of illumination during a multi-second exposure will blur the image of the specular highlight on the film. If, over time, the light source can be made to cover a larger area, the edge of the specular highlight will also cover a larger area. For instance, if the source is moved over a four times larger area, as in the

Moving the light further away to throw the specular edge more out of focus started to create complications.

case of the radios, the edge of the specular highlight will cover a four times larger area too. Motion of source was the best solution for the radios shot. It allowed the specular edge transfer to be very soft edged, even though the light had to be in close to avoid crowded real estate and specular highlight size complications. It also made it possible to keep the lower radio somewhat sharp at f22 without creating a hard specular edge transfer.

Motion of source is a control that many photographers have forgotten . . .

Motion of source is a control that many photographers have forgotten, since the majority of lighting in photography is now done with strobes. Duration lighting uses lights such as tungsten lights. Tungsten lights, when filtered or combined with tungsten film, allow "pre-touching." Shaking a light source, such as a panel that has wrinkles over its diffusion fabric, for a several second exposure, will blur any wrinkles seen in the specular highlight into non-existence.

Fragrant Confusion (pages 89–92) required serious problem-solving. The client was Tristar Pictures. The image was to appear in the film *Look Who's Talking Now*, starring John Travolta and Kirstey Alley, as a 4' x 5' print on the wall of a perfume executive's high tech office. The challenge was to capture a clear, crisp product/beauty shot that was also an action shot of a perfume bottle in flight, with liquid splashing out of its spout. Throwing the bottle through the air and hoping to have it pass through the set at the right angle and position, at the right depth in the camera frame for sharpness, with liquid spilling out of it perfectly would probably have taken tens of thousands of frames of film. Try exposure bracketing that!

The solution was pretty devious. We set the perfume bottle on top of a sheet of glass, positioning the camera directly over top of the bottle so that the bottle blocked it's own reflection from the camera's point of view. A Wratten 81A warming filter and a double layer of black tulle were attached to the back of the lens for all exposures. The camera, the camera studio stand, and the ceiling were all black in color so that their reflections on the glass could not register on film.

The perfume bottle, which was custom created by a local glass artist, was injected with stiff hair gel that was colored with yellow food coloring dye. Stiff gel was chosen so that it would sit up and appear "chunky" in order to mimic liquid sloshing around inside the bottle. The liquid splash was not a liquid at all. It was made out of a resin material by one of the model makers on the film.

To add depth within the speculars (from the main-light) on the surface of the bottle, a soft specular edge transfer was created by keeping the strobe head close to the Plexiglas light source.

Specular edge transfer can be made harder or softer by moving the origin further from or closer to the source. Moving the origin far enough away from the source disperses the light over the source's diffusion material so that it is lit evenly from edge to edge. This creates a hard specular edge transfer (assuming the subject's surface is shiny, and the specular highlight is within the camera's depth of field). Moving the origin closer to the source increases the light energy hitting the center of the panel. This decreases the light energy striking the edges of the panel—the light dispersement over the diffusion fabric then gradates from bright in the center to dark at the panel edges. A reflection of this effect is seen on the surface of the subject within the specular.

The gradual tonal change from the specular's bright center to its darker edges adds a rich quality to the perfume image. The strobe head was placed close to the Plexiglas material to create a gradated puddle of light. We made sure that some of the strobe's light hit the edges of the Plexiglas to a high enough value that they would register on film. If the edge of the light source does not register on film, because the light has fallen off too much, the resulting specular will give the surface of the subject a matte look. It will appear as though it were sand-blasted or sprayed with a matte lacquer finish.

To add magic sparkles to the perfume bottle and the resin splash, another light was added to the set and exposed independently from the other lights to create selective softening. Placed on the camera-left side of the glass tabletop surface and aimed directly at the subject, a 250 watt tungsten light fitted with a projection lens produced a narrow beam of light that made the bottle and the perfume splash "sparkle." This light was intentionally not color corrected for the daylight balanced film. This created a warm color shift on film. During the tungsten accent light exposure, a 4" x 5" acetate film sleeve smeared with the natural (or perhaps somewhat un-natural) oils from the author's greasy forehead was held in front of the lens. This filthy, heavy softening filter made the bright speculars from the accent light flare out for a magical glowing effect and created a $-^2/_3$ stop filter factor. The fact that this light was relatively small and relatively far away produced bright sparkles (speculars of high specular contrast). These small speculars appeared brilliant even though their source was underexposed by $2^1/_2$ stops. An incident meter reading of the light striking the subject from the tungsten source read f8$^1/_2$ ($2^1/_2$ stops below the f22 camera setting). End result? The light makes very

This light was intentionally not color corrected for the daylight balanced film.

Frame 53—A 4' x 5' sheet of ⅛" thick opaque white Plexiglas was placed perpendicular to the glass tabletop surface just outside the top of the 4 x 5 view camera frame. The origin to the Plexiglas light source is a White Lightning Ultra 1800 studio strobe positioned two feet behind it.

Frame 54—To add magic sparkles to the perfume bottle, a 250 watt tungsten spot light was attached to a light stand and placed on the camera left side of the glass tabletop surface and aimed at the bottle. A heavy softening filter was placed over the lens.

small, bright specular highlights while creating little exposure on the diffused values.

The background was an inexpensive solution. The word "confusion" was created in a computer. It was printed out on regular paper, then enlarged on a large photocopier. The photocopy was then photocopied. This new copy was photocopied. Then the latest copy was photocopied. This degraded the type with several generations of quality loss, creating noise on the printout. The noise created soft gradations of tone behind the type, adding depth to the background.

Frame 55—The background came to life when lit with a 1000 watt Altman tungsten light, placed on a short stand on a box on the floor on the camera right side of the set.

Frame 56—To affect specular edge transfer for comparison's sake, the strobe origin is moved further away from the Plexiglas main light source.

The final photocopy was placed on the floor below the glass tabletop, so that the camera looked through the glass down to the photocopy. To add depth to the overall image, the background was intentionally beyond the camera's depth of field (out of focus). The background came to life when lit with a 1000 watt tungsten light, placed on a short stand to the camera-right side of the set and pointed directly at the photocopy. To make the background take on a warm color balance on film, the light source was left uncorrected for daylight film.

Frame 56 was a variation done for comparison's sake. The strobe was moved away from the Plexiglas main light source. Its light evenly covered the surface of the Plexiglas sheet. Notice how the specular

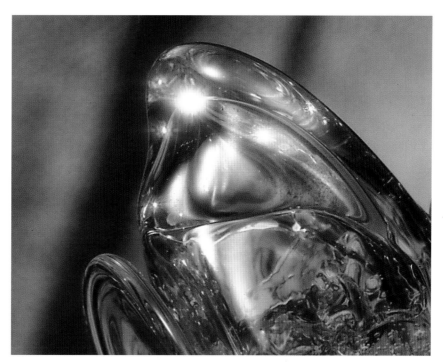

Frame 57

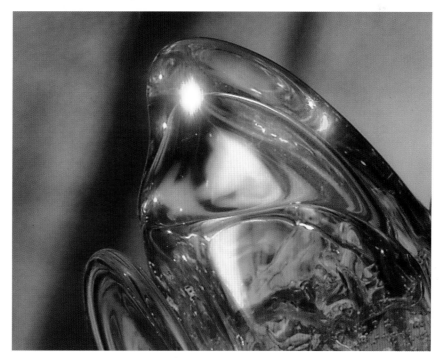

Frame 58

edge transfer is harder edged. Its reflection on the bottle looks like the Plexiglas panel, with an even tone from edge to edge. The speculars from this source on the bottle appear flatter when compared to Frame 55. For a closer look, view Frames 57 and 58. Compare the edge transfers of each.

Data for Frames

FRAMES 53, 54, 55, 56, 57 AND 58:

Camera Exposure Setting: f22, shutter set on bulb. Room lights were off for all exposures.

Exposure One: Shutter opens, strobe fires two times, shutter stays open for a total of 16 seconds burning in the background exposure.

Exposure Two: The 250 watt tungsten "sparkle" spot light is exposed for eight seconds.

Filtration: Wratten 81A filter, double layer of black tulle on back of lens, dirty 4" x 5" acetate film sleeve placed over lens for second exposure only.

Camera: Sinar P2 4 x 5

Lens: Rodenstock 240mm

Film: Kodak VPS 160 rated at 80 ISO (4 x 5 daylight-balanced color negative) and Kodak Ektachrome 100 Plus rated at 80 ISO.

Reducing the distance of origin to source creates liquid-looking speculars that have a soft airbrushed look with a three-dimensional feel. This is also an attractive effect on things other than glass. It works equally well on mid- to dark-toned objects such as automobiles and other shiny objects like silverware. I particularly love using this effect to improve the appearance of poor quality subjects. Imagine a cheap, shiny red car with a specular on the surface of the red paint. The specular gradates gradually from its bright center into the red tonality of the paint creating a luxurious luster that greatly heightens the automobile's perceived value (truth in advertising?).

Origin distance is crucial when manipulating specular edge transfer with this control.

As stated earlier, but worth repeating, origin distance is crucial when manipulating specular edge transfer with this control. If the origin is moved close enough to the diffusion fabric, the edge transfer will end before reaching the edge of the panel. The actual edge of the panel will not record on film. The specular will appear so soft edged that the subject's shiny surface will look matte.

This gradated specular effect cannot be done with a standard soft box because the distance of the origin (the strobe) from the diffusion material is fixed. You cannot move the strobe closer to the diffusion material to alter the light dispersement over the fabric's surface.

SPECULAR CONTRAST

Specular contrast refers to the brightness of the specular relative to the diffused value. For instance, a specular contrasts less on a white diffused value than on a black diffused value (the brightness difference between a light tone and an intense specular is very small). The same specular on a dark tone would create a greater tonal difference (greater specular contrast). It makes sense, then, that speculars create more noticeable shape and form on darker tones than on lighter tones.

The Austin Healy sports car (Frames 59 through 63) had a dark blue paint job, but the client wanted the car to appear black and planned on having it digitally retouched. This was unnecessary. By underexposing the dark blue paint, it was very easy to make it record as black on film. The car's diffused value was exposed on film to appear four stops darker than middle gray (–4 black). From this point on we treated it as a black car instead of a dark blue one.

A dark object such as the Austin Healy offers tremendous specular brightness range possibilities. To show shape and form on a –4 tone, shadow would be a poor choice because it offers little contrast. A better choice was to wrap specular highlights over the car's dark body to show off its roundness and various angles. The range brightnesses that create workable contrast on black is great. The specular brightness on a –4 diffused value could be any tone from a $-3^2/_3$ value up to a $+2^1/_3$ brightness (pure white)—twenty tones to choose from! There are four controls for specular contrast:

1. Size of light source
2. Distance of light source to subject
3. Surface efficiency
4. Tonal efficiency

SIZE OF LIGHT SOURCE

Specular contrast can be controlled by altering the size of the light source. For instance, if a specular appeared pure white on a subject's surface, that specular would be completely opaque (you would not be able to see through the specular highlight to the diffused value underneath). To see through to the subject's surface detail, reduce the specular contrast by making the specular more translucent. In other words make that specular less bright.

If a 2' x 3' softbox produced a pure white specular with a reflective reading of three stops above middle gray, no detail of the diffused

Frame 59—An undiffused Metz CT-60 flash mounted on top of the camera acts as a main light for the vintage Austin Healy sports car.

value would be seen through the specular highlight. To reduce the specular's brightness, enlarge the light source (e.g. use a larger softbox). For instance, to make the specular drop to ¼ of its original brightness (+3 down to a +1 value), switch to a softbox that is four times bigger (e.g. two times wider by two times longer equals a 4' x 6' softbox). Switching to a 4' x 6' softbox would make the specular on the subject four times bigger. The specular energy would have to cover a four times larger area, diminishing the specular to ¼ of its original brightness.

How energy diminishes over a larger area is simple to understand. Say you had eight ounces of coffee sitting 8" deep in a mug. If the coffee were spilled onto the floor, there would still be eight ounces of coffee, but its depth would have decreased from 8" to a fraction of an inch. In other words, it would be much shallower. It would still be

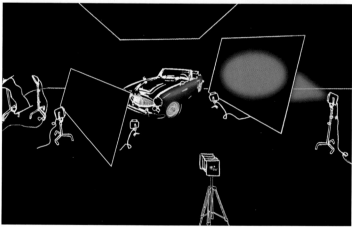

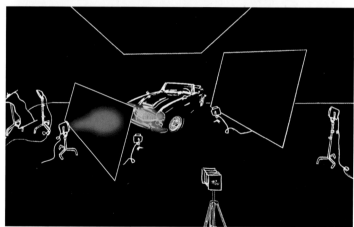

Frame 60—The on-camera flash is replaced with a larger main light. A 20' long by 9' high Chimera Ultimate Support frame made of aircraft aluminum tubing is placed alongside the car. Inexpensive bleached white muslin is stretched over the frame. The origin to the white muslin source is provided by a 1000 watt Red Head tungsten lamp. Its light energy is projected down the backside of the muslin.

Frame 61—The chrome on the front of the car comes to life with the addition of a 6.5' x 6.5' PVC tubing frame with two layers of white nylon stretched over it. A 250 watt tungsten lamp projects its light energy through the panel on to the chrome. The car headlights are turned on.

the same amount of coffee, but in a larger area it has less depth. Think of the intensity of a specular as the depth of the coffee: the more area it covers, the less depth or brightness it has. (Baking soda is great for removing coffee stains off white linoleum, by the way).

For lighting, the size of the source is determined relative to the size of the subject. A 4' x 6' light source placed close to a human sub-

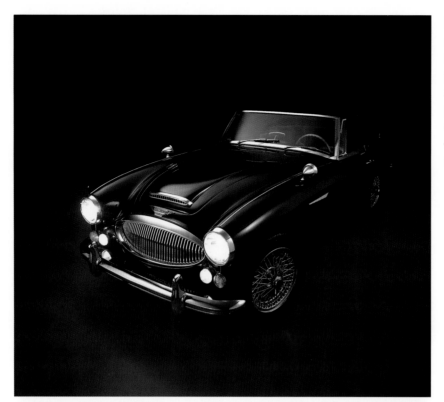

Frame 62—To create large soft-edged speculars on the Healy's top surfaces, a 30' x 18' reflector is suspended over the car. Two 1000 watt Altman fresnel tungsten spot lights placed on the floor on either side of the Healy create soft-edged puddles of light on the underside of the reflector.

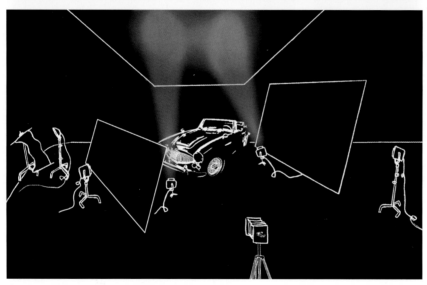

ject is generally considered a large source of illumination. That same source placed close to an automobile is generally considered very small. Frame 59 of *Austin Healy* proves this point. The small strobe light source, which is a $4\frac{1}{2}$" x 3" light source, creates minute speculars of very high specular contrast. They contrast sharply with the dark paint's diffused value. These reflections of the flash are so intense that they are totally opaque (no detail of the underlying surface shows through). This high contrast is caused by the light source's relatively small size. All the energy of the flash that is

Frame 63—As a variation, dry ice fog creates a misty effect on the floor around the Healy. A Plexiglas mirror, which is bent and twisted, is placed in front of the car just out of camera frame. A 1000 watt Red Head tungsten light is directed onto the mirror. The distorted surface of the mirror reflects a misty nebulous shape onto the cove wall behind the Healy.

required to create the right exposure of the Healy is compressed down to a very small reflection. The speculars in Frame 60, created by a 20' x 9' light source, contrast less against the Healy's dark surface. The reflection of the light source is spread out over a relatively large area, diminishing its brightness.

Data for Frames

FRAMES 59, 60, 61, 62 AND 63:

Camera Exposure Setting: f16 on bulb for 30 seconds. Frontal square light source shut off after 15 seconds. 30 second exposure for headlights due to low car battery charge. All room lights were off for all exposures.

Filtration: Wratten 81A filter, double layer of black tulle on back of lens.

Camera: Sinar P2 4 x 5

Lens: Rodenstock 90mm (wide angle)

Film: Kodak 64T rated at 64 ISO (4 x 5 tungsten transparency film)

If speculars were made of water rather than light, the volume of specular energy caused by a small source could be 1000 ounces of water. If this 1000 ounces were spread over a one inch square area of the car, the water would be of great depth (a brighter specular—higher specular contrast). If that same volume of water were instead spread out over a 33 square foot area of the car's surface, the water would be more shallow (less bright specular, lower specular contrast) and detail of the underlying surface (the car's diffused value), would show through.

■ PRETOUCHING:

MOTION OF SOURCE TO SOFTEN SPECULAR EDGE TRANSFER

This control was useful when lighting the Austin Healy. Light was bounced off a giant panel hung from the ceiling above the automobile. Inexpensive stage spotlights (placed on the floor out of frame and pointed up onto the under side of the panel) served as origins to the giant panel source. This panel was constructed with two sheets of 9' wide, white seamless paper stretched over an 18' x 30' frame made of Chimera Ultimate Support light weight aluminum tubing. The seam created down the middle of the panel (where the white seamless papers are taped to one another) showed up on the surface of the automobile. To pretouch this imperfection seen in the specular, the panel light source was suspended from the ceiling by rope. During the thirty second exposure, the panel was rocked back and forth. The rocking blurred the edge of the seam, making it invisible. It also softens the edges of the giant panel's reflection on the car's surface.

Light was bounced off a giant panel hung from the ceiling above the automobile.

This technique creates a very soft specular edge transfer (the gradation from specular to diffused value is spread out creating an attractive airbrushed look to the car). The side panel (as described in the Frame 60 description) and the front panel (as described in the Frame 61 description) were shaken during the exposure to blur the fabric wrinkles.

BIG RED

Not all tabletop photography has to be done in a studio environment. For someone starting out in photography, creating images of small objects is ideal. A red pepper is a relatively small subject and the whole set placed around it takes up very little space. This makes it possible to shoot inside a small room. In fact the *Big Red* image (pages 101–103) was created in a kitchen. It was placed on the top

Cheap Solutions

Here's a cheap solution for photographic tightwads. Shooting automobiles has traditionally been an expensive proposition equipment-wise, and not an area of photography entered into by tightwads. However, a little knowledge could open up automobile photography to the tightest of wads. Typically a shot like "Austin Healy," would have been done with a massive soft box with multiple strobe heads inside suspended above the car (a $30,000 to $40,000 investment). However, bouncing inexpensive tungsten stage spot lights off the underside of two 30' lengths of white seamless paper taped together and taped to a frame (made of wood or light weight aircraft aluminum tubing), creates a much cheaper, more controllable light source. But it gets better! This cheap solution requires less ceiling height, making it ideal for smaller studios. And it gets better still. You see, softboxes provide little to no control over specular edge transfer, whereas panel light sources provide infinite control. Tungsten lights mean tungsten film, so long exposures of up to 100 seconds are possible without reciprocity effect with some films. These long exposures allow pre-touching of less than perfect light source fabrics (see "Pretouching). For large light sources where firing light through the panel is required, muslin material makes a great diffusion source. Muslin can be bought at stage supply stores. It is one of the cheapest materials available and comes at least 10' wide. It does, however, have a earthy tint. But have no fear, this brownie-yellow coloration can easily be bleached out in your washing machine creating a very neutral white.

of a chair back and was positioned so that the kitchen cabinets could act as a soft-edged background. By working with shallow depth of field the cabinets were thrown out of focus. Normally, we think of f8 as being a fair bit of depth of field, and it is on a larger object like a person. On a small object such as our red pepper it is surprisingly little. Keeping backgrounds very "soft" means that almost anything can act as a background.

The red pepper has a rounded surface, meaning it "sees" a large area (a large portion of the room is reflected on its surface). To create a decent sized specular on the pepper's surface, a relatively large softbox was used. However, with the 3' x 4' softbox placed 4' away from the pepper, the specular contrast was too high. Notice how opaque the specular appears in Frame 64. A softer look was wanted and the brightness of the specular was too great. For the prevailing tastes, it needed to be $\frac{1}{4}$ of its present brightness. Switching to a four times larger light source would drop the brightness of the specular down to one quarter. However available space and equipment made this an impractical solution.

By working with shallow depth of field the cabinets were thrown out of focus.

▦ DISTANCE OF LIGHT SOURCE TO SUBJECT

Changing the distance of the light source affects the brightness of speculars caused by that light. But, to reduce the brightness of the

Faking It

Faking it is usually frowned upon in relationships, but is okay when creating with light, as long as no one can tell. Sometimes a light source cannot be placed where it needs to be in order to create a specular where it is needed. In the Austin Healy shot this occurred in several spots: the rounded tail of the Healy's rear, camera right side, and the tires. Speculars were intensified and faked by spraying underarm deodorant aerosol spray onto the tire tread and onto the back tail of the Healy. The spray dries as a soft-edged white powder, and if done sparingly can fake a specular.

Did You Know?

If you cannot make a light source larger how else can you make it appear four times larger to the subject? Read the next section for the answer!

Frame 64—A 3'x4' Chimera soft box fitted with a White Lightning Ultra 1800 studio strobe is placed to the camera right side of the red pepper at a distance of 4'.

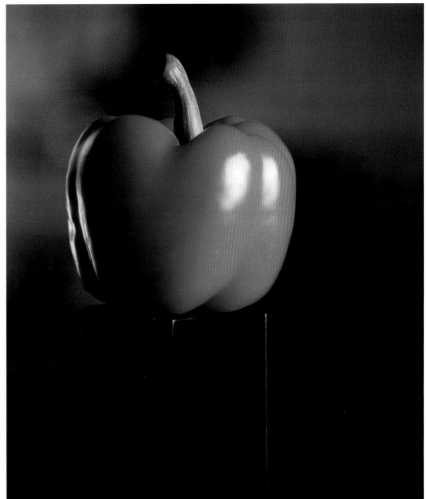

specular on the red pepper, would you move the light source further away or closer?

In Frame 65 of *Big Red*, the 4' distance of the softbox to the subject is halved (2'). Notice how the specular is altered. It appears larger, in fact four times larger, yet it appears the same brightness. How is it possible that the specular can cover a four times larger area and still be the same brightness? Moving the light source closer to the

FRAMES 64, 65 AND 66:

Exposure: f8 at 1/60 second

Filtration: Wratten 81A filter on front of lens

Camera: Hasselblad ELM

Lens: Hasselblad 150mm

Film: Kodak Ektachrome 100 Plus rated at 80 ISO

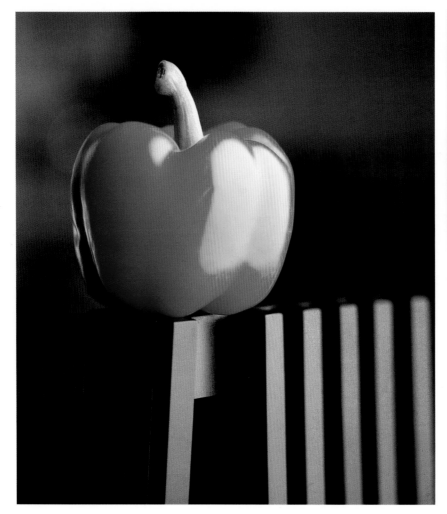

Frame 65—The distance of the soft-box main light to the pepper was halved..

subject (from 4' to 2'), will cause four times more light to fall on the subject. The specular appears to be the same brightness because the amount of light energy increased at the same rate that the specular increased in size on the red pepper. Four times more energy spread over a four times larger area equals same intensity. They cancel each other out.

Look closely at the red pepper. Apart from the specular changing in size, what else has changed? The pepper's diffused value in frame two is overexposed. For a correct representation of the pepper, this exposure needs to be adjusted so that the red surface of the pepper appears as it did in frame one. If we reduce the power of the strobe head by two stops, or select a smaller aperture (here f16, although this was not an option since shallow depth of field was needed), the pepper's diffused value will be correct.

What will this adjustment do to the specular brightness? Look at Frame 66. The pepper's diffused value is correctly exposed and the specular brightness is diminished. The new exposure brought the dif-

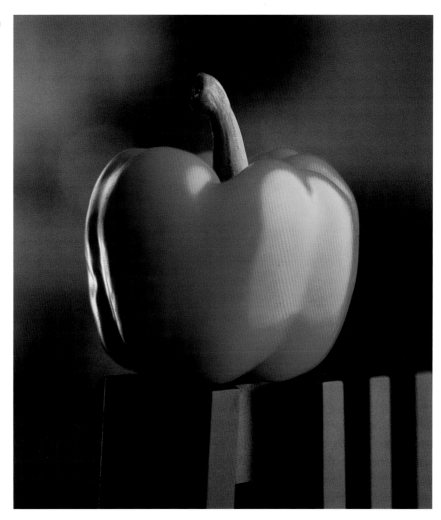

fused value back down to a correct exposure, and also dragged down the brightness of the specular. In the end, the specular appears less intense and larger, while the diffused value appears as though nothing has happened. Talk about counterintuitive!

▌ SURFACE EFFICIENCY

Surface efficiency is the ability of an object's surface to return specular energy. A smooth surface, such as the surface of a shiny automobile, allows the specular energy to stay focused on return, creating higher specular contrast. A rough or textured surface, such as the oxidized paint of an old automobile's surface, appears (on a magnified level) like the surface of the moon—a multi-angled surface made up of craters and pits. The particles of light that make up the specular strike the multiple angles of the rough surface, bouncing off in every direction. Since they cannot bounce off parallel to one another, the specular energy is broken up (spread out) creating a larger, darker specular that appears out of focus.

Laws for Squares

Specular contrast is affected by the inverse square law. If you wanted to reduce the contrast (the specular brightness) by 1/4 (make it two stops darker) decrease the distance of the light source to the subject by 1/2. Moving a light source from 4' to 2' would cause its specular on the surface of the subject to be become two times wider and two times higher. The specular would cover a four times bigger area on the subject (2 x 2 = 4). The amount of light energy would be four times greater as well, but since it's covering a four times bigger area, it would stay the same intensity. The diffused value would also receive four times more energy. Re-metering would instruct us to reduce the exposure by two stops to maintain a correct exposure. This reduces the specular's exposure on the film, making it 1/4 the initial brightness. In other words, two stops darker.

Anytime light energy increases to cover a larger area without an accompanying increase in energy, brightness will decrease and specular contrast will drop. If the specular energy were made to cover an eight times bigger area, the resulting specular would be one eighth of the intensity. This is why, in the movie industry, dulling spray is used to control distracting "hot spot." Dulling spray or matte spray can be sprayed over it to reticulate its surface. This breaks up the specular to reduce its contrast. In other words, it makes it less intense and less noticeable.

In portrait and fashion photography, makeup is very important because it helps reduce specular contrast. A person's skin naturally exudes moisture and oils, creating a smooth surface (especially when hot or nervous). This oily moisture, in conjunction with smaller light sources, creates a greasy, harsh, washed-out look. The addition of make-up transforms this "glossy" surface into a "matte" surface that spreads out the specular energy (just like matte spray on prints), making for a softer look. Compare the contrast of the specular on the front of the beer bottles in frame 46 and 47 (*Shoot-Out at OK Spring)*. The smooth surface of the gloss lacquer spray on the frame six beer label creates a more efficient surface for reflecting light.

The Christmas billiard ball image is a perfect example of creative problem solving. The client wanted a warm, dynamic billiard ball tree created for a Christmas card. Unfortunately there was no budget for retouching, and very little for propping.

The Christmas billiard ball image is a perfect example of creative problem solving.

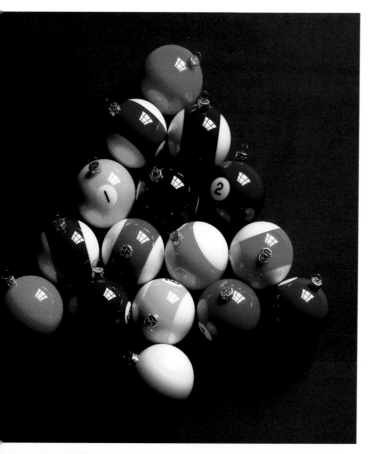

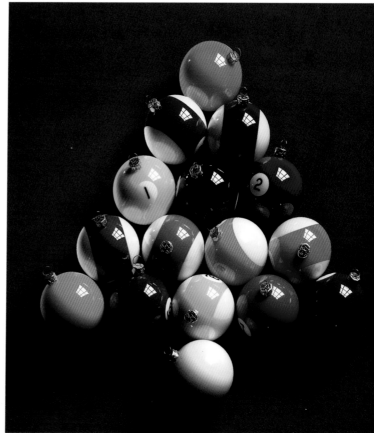

Frame 67—a 4' x 6' Chimera softbox fitted with a Speedotron 4800 strobe head, lights the billiard balls from its position behind and to the camera right side of the set. It is attached to a light stand that is extended to a four foot length and sits about six feet away from the billiard balls.

Frame 68—A slide projector is placed to the camera left side of the set four feet away from the subjects. Its color conversion gel covered lens sits at the same height as the green felt table top surface and projects a thin focused beam of light onto the camera left side of the balls.

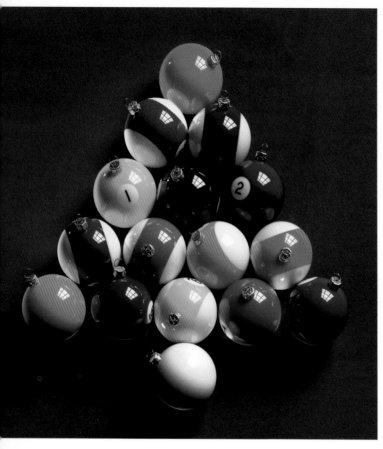

Frame 69—The front bottom edges of the balls come to life when painted with light using a daylight corrected, small, "gooseneck" flashlight.

Frame 70—Christmas lights are simulated with eight exposures of a "gooseneck" flashlight held over eight different parts of the "billiard tree." Various colored gels are held over the lens for seven of the exposures.

A billiard table was needed as a surface for the shot. Rental and delivery of a table would have grossly exceeded the propping budget. However, since the image was not going to show the sides of the table, renting just the green felt fabric was the perfect solution. The next challenge was figuring out how to place miniature Christmas lights amongst the ball cluster without wires showing. Feeding the wires through holes cut in the fabric (which retails for approximately $900.00) was not an option and would most certainly have violated the rental agreement. The solution was a cheap miniature light source, colored gels, a star filter, and fifteen separate exposures.

Time was of the essence if *Christmas Billiard Tree* was to stay within budget, and lighting multiple spheres can be a time consuming process. Using a softbox is a fast way of creating soft "wraparound" lighting on spheres, but it creates rectangular speculars that scream "fake studio shot!" Solution? Tape long pieces of black duct tape to the front nylon diffusion material of the softbox main light.

Their grid-like reflection clearly shows up within the specular high-lights caused by the softbox. Now these speculars read as window light sources.

For the rim-lighting on the camera left side of the balls, a thin band of light was needed. A slide projector fitted with a zoom lens was the perfect choice. Its beam could be perfectly adjusted using the lens' zoom and focus controls to hit just the side of the balls and not the green felt. If this light were allowed to spill onto the green felt, it would appear brighter on one side of the balls than the other, creating an unevenly lit background surface. Since the camera was loaded with daylight balanced film and the projector uses a tungsten light

Frame 72

Frame 73

Frame 74

Data for Frames

FRAMES 67, 68, 69, 70 AND 71:

Exposure: f16 (on bulb)

Exposure Procedure:

1. Strobe main-light fires, shutter stays open for 4 seconds for the projector exposure.

2. For exposures two through seven, front bottom edge of frontal billiard balls light painted for 3 seconds each.

3. For exposures eight through fifteen, simulated Christmas lights each made with 4-second exposures using "gooseneck" flashlight. All room lights were turned off for all exposures.

Filtration: Wratten 81A and softening on back of lens. For Christmas light exposure only, four different colored gels, a softening filter and a star filter.

Camera: Sinar P2 4 x 5

Lens: Rodenstock 240mm

Film: Kodak Ektachrome 100 Plus rated at 80 ISO

A fill light would have solved this, but it would have caused additional speculars.

source, a 3200°K to 5500°K color conversion blue gel was placed over the projector's lens. To determine the shutter speed required for a –1 amount of light striking the balls' sides, an ambient incident meter reading was taken with the back of the meter placed against the side of the balls, and the metering dome pointed at the light source. The meter's shutter speed was adjusted until the read-out window gave an f-stop one stop darker than the camera aperture setting (a –1 incident value).

The front edges of the balls (the base of the "tree") had little to no separation from the green felt surface. A fill light would have solved this, but it would have caused additional speculars. Using a small flashlight, fitted with a color conversion gel, to paint with light solved the problem. The flashlight was positioned about 1″ away from each of the lower balls. An exposure of three seconds was painted onto each ball separately (see Frame 72).

The trick that really created the illusion of a Christmas tree was the lights. The lightbulb head on the end of a small flashlight was positioned so that the lightbulb head sat against the top of the balls at various positions (see Frame 73). During the four second exposure of each position, a different colored gel was held over the camera's

lens giving each exposure a different color (see Frame 74). All the Christmas light exposures were done without tungsten to daylight conversion gel. Overall softening was created with a softening filter made from smeared forehead grease on a 4" x 5" acetate film sleeve. This "film sleeve filter" was placed over the back of the lens inside the camera for all exposures. The "tree light" on the top of the tree was exposed without a colored gel. Instead, a star filter was held over the front of the camera lens.

Looking at the first image of the *Christmas Billiard Ball Tree* (Frame 66), notice how the specular on the light ball barely shows up compared to the specular on the dark ball. The dark ball looks shinier than the white ball, but is it really? How could two speculars, both caused by the same light source, appear to differ in brightness? Are they actually different? To answer these questions, let us take a look at yet another control of specular contrast.

> The dark ball looks shinier than the white ball, but is it really?

▓ TONAL EFFICIENCY

Tonal efficiency is efficiency of a tone in returning light. The ability of a subject's diffused value to return light affects the perceived brightness of a specular. For instance, a new black automobile seems shinier than a new white automobile even if the speculars that create the "shine" on both cars are identical. An object with a dark tonality returns very little of the light energy that enters into its molecular structure. A low return of diffused energy is low tonal efficiency. Since low tonal efficiency creates a dark looking tone, and since a dark tone creates a greater range to create contrasting speculars on, speculars seem brighter on dark surfaces. It is not the specular's brightness, but rather the difference (or contrast) between the specular's brightness and the brightness of the diffused value that makes a black car seem shinier than a white car or a dark billiard ball shinier than a white one.

Tonal efficiency really comes into play when lighting white satin garments like wedding dresses. Shadow is the predominant light form for showing shape on white satin, however it does not identify the

Quick Reference

Tonal Efficiency: The ability of a subject's diffused value to return light. Dark objects return little light and therefore have low tonal efficiency. Light subjects return more light and therefore have higher tonal efficiency.

surface quality—the "sheen" of the fabric. The "sheen" is specularity, and since the fabric is white (white with detail, a +2 value), there is little room left to create a contrasting specular form. The contrast range is from white with detail to pure white—two stops above middle gray to $2\frac{1}{3}$ stops above middle gray. One third of a stop contrast range is not exactly attention grabbing! An excellent solution to this minimal contrast range is selective underexposure of the diffused value. When lighting a white satin garment I often use a large softbox to create overall light. This softbox is underexposed by $\frac{2}{3}$ to $1\frac{1}{2}$ stops. To show that the garment is white not gray, spot gridded accent lights are directed onto select areas. In the darker areas, bright speculars from these small light sources run up and down the folds of the material showing the sheen quality of the satin fabric.

▨ CUTTING EDGE

What is the true tonality or diffused value of these chrome-plated scissors?

In Frame 75 (*Cutting Edge*), what is the true tonality or diffused value of these chrome-plated scissors? That question is actually a little unfair because metallic surfaces do not have diffused values. But if the scissors have no diffused value, how do you light them?

Highly reflective surfaces, such as chrome and silverware, have given more than one photographer gray hair. If you think of these surfaces as mirrors your job becomes much easier, and your need for "Grecian Formula" diminishes. To show off the chrome surface of an object you have to rely solely on speculars. Since the scissors are made of metal, their molecular structure is so condensed (the molecules are so tightly spaced) that no particles of light can penetrate. All the energy bounces off the surface of the metal. This means that there is no diffused value, no true tonality. The scissors' tone is really the tone of whatever it happens to be reflecting. Since speculars are used to light metallic surfaces, the placement of the light sources must be viewed from the camera in order to see their true effect (this is called angle sensitive lighting).

A round, wooden antique table was used as a table top surface. Its dark wood adds an interesting contrast (cold steel against warm wood). The softbox main light does more than just coat the surface of the scissors with its reflection, it pulls double duty on this shot. It acts as main light to the scissors and fill light to the rest of the props and the table surface.

Notice how the scissors are brightly illuminated, and how underexposed everything else is (see Frame 75). An incident meter reading of the light hitting the scissors and the surrounding set from the soft-

Figure 75

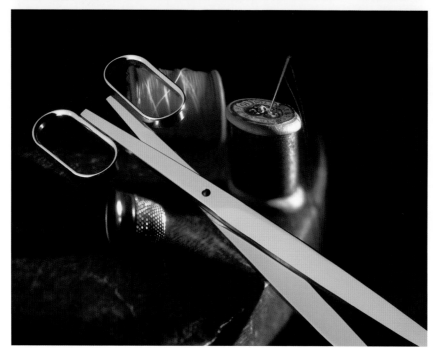

Figure 76

box reads f2^5/$_{10}$. Since the camera lens aperture is set to f5.6, the affect of this light is underexposed by 2½ stops, called a −2½ incident value. If the softbox had been used to light the whole set to a correct exposure, the resulting image would have a very flat-lit, lackluster look. Even with the softbox underexposed, the brightness of the specular highlight on the scissors is quite bright.

With the scissors lit to the desired brightness, it was apparent that the softbox was too large and in the wrong position to create the dra-

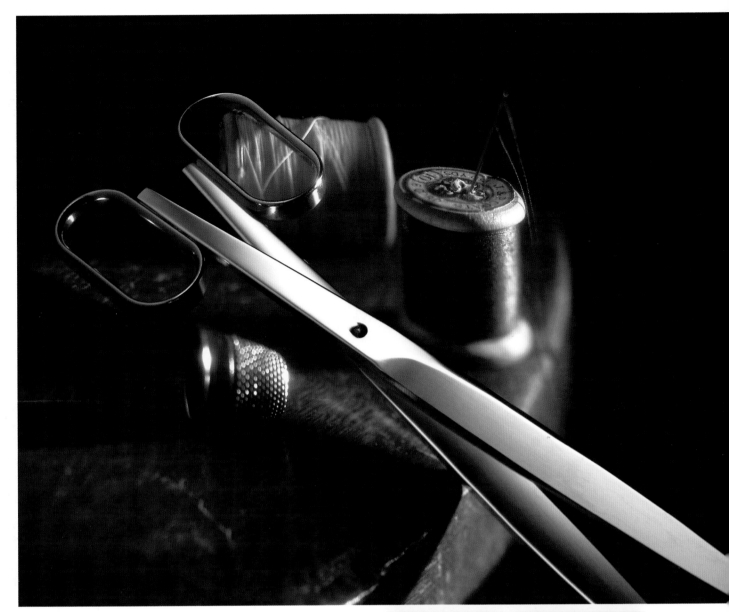

Frame 77

The Hard Way

A long time ago, I learned the lighting trick used in the scissors shot (underexpose the light that is creating the speculars) the hard way. Mark and I were shooting a car with a lot of chrome on it in our studio. We had been very careful about removing or covering with black cloth any objects in the studio that might show up as unwanted reflections on the chrome surfaces. Even the tubes in the studio's fluorescent ceiling light fixtures were considered, but were left alone because they were far enough away from the set lights that they would not reflect any significant amount light down onto the car. However, on the last set-up of the car, the florescent room lights were turned on for a quick focusing check. We forgot to turn them off before making those last exposures. As a rule in our studio, when shooting with strobe lights, the camera's shutter speed is set at 1/60 second. This is fast enough to cancel out the room lights if they happen to be on, and it was the fastest safe shutter-sync speed for most 35mm cameras at the time. We realized our mistake after taking the shot, but thought nothing of it because we had shot it at 1/60 second. The next day when we got the film back, everything was great except for the last shot, which had funny looking green reflections on the car's chrome. At that point, we realized that our shutter speed setting was fast enough to cancel the florescent light exposure of the car, but not fast enough to cancel out the reflections (the speculars). We learned the hard way that if the light source is small enough and/or far enough away, speculars can be many times brighter than the diffused value, therefore they can still create an image on film even when the diffused values are so underexposed that they do not register on film. Gulp! Fortunately we had not torn down the set, so we shot again with the room lights off. From this near tragedy a great technique came to light: I realized that the light source that creates the speculars on the set does not have to be the same source that lights the diffused values to the desired brightness.

matic, hard-edged, elongated shadows that were needed for the rest of the set. A second light source was needed. A strobe head with a reflector and nothing else affixed to its front was positioned to skim its energy across the set from a low angle (see Frame 76). An incident meter reading of the light striking the set from this strobe head read f11, a +2 incident value (two stops overexposed).

On the second exposure, the backlight strobe was turned on and the softbox strobe was turned off. A forehead-grease-smeared 4" x 5"

film sleeve was held over the lens for this second exposure only. This way, the effect of this light was heavily softened, whereas the softbox exposure for the scissors remained relatively sharp. This exposure technique is called "selective softening." This is not to be confused with "selective sharpness." In the case of the scissors, selective sharpening was achieved through a combination of shallow depth of field and swinging and tilting the rear standard of the 4 x 5 view camera. This creates a line of sharpness running along the scissors.

The softening technique used in the second exposure had another advantage. It allowed us to completely cover the softbox front with a black cloth for the second exposure only. This prevented light from the second source "ricocheting" off the front of the softbox onto the set, which would flatten the shadow contrast. Softboxes are designed to disperse light from the interior strobe head evenly from edge-to-edge over the front diffusion material. Since the front of the softbox is evenly lit, its reflection on a shiny surface will appear as a constant tone from edge to edge. This created a slight problem with the scissors shot. The problem was, the scissors appeared as though they had a diffused value—white. The scissors looked like they were made out of white plastic. This is a typical problem photographers run into when lighting silverware with softboxes. To solve this problem, they often move the softbox so that its edge shows up on the surface of the subjects. The result is a white and black "zebra striped" subject. Where the softbox's reflection ends, the darkened room reflection on the silver surface begins. This look is somewhat harsh, and very contrasty.

For *Cutting Edge*, a softer look was needed to show off the shape of the scissors. This meant creating a soft specular edge transfer from the brightest point of specular into a darker tone. As we saw on the

> The problem was, the scissors appeared as though they had a diffused value— white.

Tech Tip

As we learned in the red pepper image and the Austin Healy image, altering size and distance of the light source allows complete control over specular contrast. You can also control the brightness of the specular separately from the brightness of the diffused value. If you want to under-expose a light source to under light or fill light the subjects' diffused values (while keeping the speculars bright), either back your light source further away, make it smaller, or use a combination of the two, then underexpose the image.

Confusion Perfume image, placing a light origin close to a diffusion source such as white Plexiglas, would create the effect. However, a softbox is faster to work with. Since the shooting aperture was f5.6 (for very limited depth of field), the image of the softbox reflected on the scissors was out of focus. With a little trial and error, the perfect position was found. A 6" length of black duct tape was then stuck to the front surface of the softbox. This tape blocked out part of the specular and, since it was out of the f5.6 sharp zone, created a very soft gradation from the bright specular from the softbox into the darker tone of the black duct tape. This was a perfect solution for showing off the "cut" of the scissors' blades. This control is called "specular gobo."

This was a perfect solution for showing off the "cut" of the scissors' blades.

■ SPECULAR GOBO

Placing a gobo (a go-between) in front of a light source blocks a portion of the source's image from the subject's surface and allows the subject's true tone to show through. A specular gobo is an object that blocks part of the reflection of the light source from the surface that the specular is imaging on. It allows you to see through to the subject's diffused value underneath the specular. In the case of a piece of silverware or chrome-surfaced object like the scissors, there is no true tonality, so only the tone of the gobo shows up. If the scissors were made of shiny green plastic, the green diffused value would show through the specular in the area where the gobo blocked the image of the softbox.

A specular gobo can be made by placing a piece of tape or paper on the front or back surface of a light control panel or a soft box's front diffusion material. Placing the gobo on the front creates a more pronounced effect, whereas placing it on the rear creates a more subtle effect. The sharpness of the gobo's edge transfer can be controlled with camera f-stop, distance of the light source, motion of the gobo (if tungsten lights and a time exposure are used), and distance of the camera. Creating specular gobos on panels offers further control. It is very easy to block part of the origin (e.g. a strobe) from the source (the panel's fabric), by placing an obstruction between the two. This

Quick Reference

Specular Gobo: Blocks a portion of the light source from the subject, allowing the subject's true tonality (diffused value) to show through the specular.

creates a shadow on the back side of the panel, reducing the brightness in that area. The mirror image of the light source (the specular) appears on the surface of the subject with a portion of its brightness reduced. This area allows more of the diffused value to show through.

To create a softer edge transfer, position the obstruction further away from the panel (closer to the origin). To create a harder edge transfer, position the obstruction closer to the panel (further from the origin). This would be the perfect technique if the scissors image needed everything in the image sharp. If everything needed to be sharp, an aperture of f32 or f45 would have been needed. This would have rendered the tape gobo in focus, creating a sharp specular edge transfer.

■ INTERRELATIONSHIPS

Interrelationships breed complexity. So far, we have looked at the separate elements and their controls that make up the foundation of "creating with light." There is, however, a lot more to consider. There are the inter-relationships between elements and controls (two or more elements may share the same control). To keep compromise to a minimum, careful consideration is necessary when choosing a control.

For instance, if a specular edge transfer were hard edged (meaning that the reflection of the light was within the depth of field sharp zone), unwanted details of that source might show up on the surface of the subject. If you chose to back the light away to pull it out of the sharp zone, specular contrast would become higher, shadow contrast would become lower, and shadow edge transfer would become harder. A better solution might be camera f-stop, or motion of the source—yet each of these controls have compromises too.

Sometimes, you may want to combine effects that are impossible to have together—for example, hard shadow edge transfer with low specular contrast. Hard edge shadow requires a light source that is small and/or far away, whereas low specular contrast requires a relatively large source positioned in close. Recall, this is the very same dichotomy that came with the scissors image. The scissors needed to be painted with a medium-high intensity specular while maintaining relatively hard-edged, elongated shadows from the subjects on the dark wood surface. The solution was to use two light sources: one small source to light the set and to cast hard-edged shadows, and another large source to create a specular on the scissors. Separating

Sometimes, you may want to combine effects that are impossible to have together . . .

 Warning!

Using a specular gobo is a great way to create specular edge transfers. However, be aware that the gobo blocks some of the light from your subject. You need to re-meter if the exposure is to stay consistent. The meter will tell you to increase the exposure for the light loss. Increasing the exposure, the diffused values (if there are any) of the subject will once again be restored to their previous brightness. However, the speculars will appear brighter, creating higher specular contrast. Adding the tape to the front of the softbox on the scissors shot did nothing to the scissors diffused value, because they had none. It did however affect the diffused values of the sewing implements and the table around the scissors that were fill-lit by the softbox. Turning the power up on the strobe in the softbox to restore the previous fill exposure makes the specular on the scissors appear brighter. This did not present a problem since there was a lot of dark toned area from the gobo on the scissors, gradating gradually into the true specular. Thinking in terms of specular contrast, adding a specular gobo is like making your light source smaller.

the specular lighting from the overall lighting made it possible to turn the power down on the large source to create medium-high intensity lighting that would not cancel out the shadow form from the small source. This large source was still bright enough to create the perfect medium-high intensity specular on the scissors' highly reflective surface. To tweak the effect of the large source's brightness on the scissors relative to its effect on the wood, I carefully inched it away until the ratio of the specular brightness on the scissors (relative to the amount of light on the table) looked right. In the end, the light from the large source striking the table read three stops underexposed (incident reading), while its specular on the scissors gradated (via specular gobo) from $2\frac{1}{3}$ stops above mid-gray to one stop below mid-gray (reflective spot-meter readings).

It seems that many of the controls will affect one or more areas that you want left alone. This is why it is important to fully understand the foundation of light control so that you can think about how each control will affect each of the other areas before making your choice. A typical comment from photo-art students is "I'm not into technical—it stifles my creativity." In reality, technical foundations can indeed stifle your creativity, because they can take all of your concentration. But, if you discipline yourself to put in the time and com-

It seems that many of the controls will affect one or more areas that you want left alone.

mit this information to your subconscious, then you can totally free your mind to create, explore, and develop your visions. You will be able to arrive rapidly at unique solutions instead of getting bogged down with trial and error. I hope the contents of this book have helped you in your pursuit for total creative freedom in photography.

About the Author

Dave Montizambert owns and operates Montizambert Photography located in Vancouver, B.C. (Canada). For the past twenty-one years, he has created images for clients such as: McDonald's Foods, Motorola, Atlanta Scientific/ Nexus Engineering, TriStar Pictures, Warner Brothers, Cuervo Tequila, J&B Scotch, and No Fear Sports Gear.

Dave lectures internationally on lighting, metering/zoning, and digital image manipulation. For the past twelve years he has been the lighting and advertising instructor at Western Academy Photo College in Victoria, B.C.

Dave's work and articles have appeared in, *Professional Photographer* and *Digital Pro Magazine* in the U.K., *Photo Life* and *Professional Photographers of Canada* Magazine in Canada, *Professional Photographer Storytellers* and *PhotoMedia Magazine* in the United States.

He also does many portraits of executives for annual reports and shoots dramatic black & white images of musicians for CD covers. Additionally, Dave does celebrity portraits for the film industry. Most recently he photographed members of Our Lady Peace, Tragically Hip, and Pearl Jam, as well as actor Patrick MacNee from the British TV series *The Avengers*, actor Hal Linden from the TV series *Barney Miller*, and actor/comedian Leslie Nielsen from *Naked Gun* and *Wrongfully Accused*.

His work has won Georgie, Lotus, Hemlock, Studio Magazine, CAPIC, and Graphex awards.

Dave can be contacted through his publisher, or via e-mail at montizam@axionet.com.

Index

Other Books from
Amherst Media

Also by Dave Montizambert . . .

Professional Digital Photography

TECHNIQUES FOR LIGHTING, SHOOTING AND IMAGE EDITING

From monitor calibration, to color balancing, to creating advanced artistic effects, this book provides photographers skilled in basic digital imaging with the techniques they need to take their photography to the next level. Each technique is explained step by step and fully illustrated for ensured success. $29.95 list, 8½x11, 128p, 120 full-color photos, order no. 1739.

Outdoor and Location Portrait Photography
2nd Edition
Jeff Smith

Learn how to work with natural light, select locations, and make clients look their best. Step-by-step discussions and helpful illustrations teach you the techniques you need to shoot outdoor portraits like a pro! $29.95 list, 8½x11, 128p, 60+ full-color photos, index, order no. 1632.

Wedding Photography:
CREATIVE TECHNIQUES FOR LIGHTING AND POSING, 2nd Edition
Rick Ferro

Creative techniques for lighting and posing wedding portraits that will set your work apart from the competition. Covers every phase of wedding photography. $29.95 list, 8½x11, 128p, full-color photos, index, order no. 1649.

Professional Secrets of Advertising Photography
Paul Markow

No-nonsense information for those interested in the business of advertising photography. Includes: how to catch the attention of art directors, make the best bid, and produce the high-quality images your clients demand. $29.95 list, 8½x11, 128p, 80 photos, index, order no. 1638.

Infrared Photography Handbook
Laurie White

Covers black & white infrared photography: focus, lenses, film loading, film speed rating, batch testing, paper stocks, and filters. Black & white photos illustrate how IR film reacts. $29.95 list, 8½x11, 104p, 50 b&w photos, charts & diagrams, order no. 1419.

Creating World-Class Photography
Ernst Wildi

Learn how any photographer can create technically flawless photos. Features techniques for eliminating technical flaws in all types of photos—from portraits to landscapes. Includes the Zone System, digital imaging, and much more. $29.95 list, 8½x11, 128p, 120 color photos, index, order no. 1718.

Black & White Portrait Photography
Helen T. Boursier

Make money with b&w portrait photography. Learn from top b&w shooters! Studio and location techniques, with tips on preparing your subjects, selecting settings and wardrobe, lab techniques, and more! $29.95 list, 8½x11, 128p, 130+ photos, index, order no. 1626

Professional Secrets for Photographing Children
2nd Edition
Douglas Allen Box

Covers every aspect of photographing children on location and in the studio. Prepare children and parents for the shoot, select the right clothes capture a child's personality, and shoot storybook themes. $29.95 list, 8½x11, 128p, 80 full-color photos, index, order no. 1635.

The Art of Infrared Photography, 4th Edition
Joe Paduano

A practical guide to the art of infrared photography. Tells what to expect and how to control results. Includes: anticipating effects, color infrared, digital infrared, using filters, focusing, developing, printing, handcoloring, toning, and more! $29.95 list, 8½x11, 112p, 70 photos, order no. 1052

Wedding Photojournalism
Andy Marcus

Learn the art of creating dramatic unposed wedding portraits. Working through the wedding from start to finish you'll learn where to be, what to look for and how to capture it on film. A hot technique for contemporary wedding albums! $29.95 list, 8½x11, 128p, b&w, over 50 photos, order no. 1656.

Studio Portrait Photography of Children and Babies
2nd Edition
Marilyn Sholin

Learn to work with the youngest portrait clients to create images that will be treasured for years to come. Includes tips for working with kids at every developmental stage, from infant to preschooler. Features: lighting, posing and much more! $29.95 list, 8½x11, 128p, 90 full-color photos, order no. 1657.

Photo Retouching with Adobe® Photoshop®
2nd Edition
Gwen Lute

Designed for photographers, this manual teaches every phase of the process, from scanning to final output. Learn to restore damaged photos, correct imperfections, create realistic composite images and correct for dazzling color. $29.95 list, 8½x11, 120p, 60+ photos, order no. 1660.

Macro and Close-Up Photography Handbook
Stan Sholik & Ron Eggers

Learn to get close and capture breathtaking images of small subjects—flowers, stamps, jewelry, insects, etc. Designed with the 35mm shooter in mind, this is a comprehensive manual full of step-by-step techniques. $29.95 list, 8½x11, 120p, 80 photos, order no. 1686.

Innovative Techniques for Wedding Photography
David Neil Arndt

Spice up your wedding photography (and attract new clients) with dozens of creative techniques from top-notch professional wedding photographers! $29.95 list, 8½x11, 120p, 60 photos, order no. 1684.

Infrared Wedding Photography
Patrick Rice, Barbara Rice & Travis HIll

Step-by-step techniques for adding the dreamy look of black & white infrared to your wedding portraiture. Capture the fantasy of the wedding with unique ethereal portraits your clients will love! $29.95 list, 8½x11, 128p, 60 images, order no. 1681.

Practical Manual of Captive Animal Photography
Michael Havelin

Learn the environmental and preservational advantages of photographing animals in captivity —as well as how to take dazzling, natural-looking photos of captive subjects (in zoos, preserves, aquariums, etc.). $29.95 list, 8½x11, 120p, 100 photos, order no. 1683.

Photographing Children in Black & White
Helen T. Boursier

Learn the techniques professionals use to capture classic portraits of children (of all ages) in black & white. Discover posing, shooting, lighting and marketing techniques for black & white portraiture in the studio or on location. $29.95 list, 8½x11, 128p, 100 photos, order no. 1676.

Dramatic Black & White Photography
J.D. Hayward

Create dramatic fine-art images and portraits with the master b&w techniques in this book. From outstanding lighting techniques to top-notch, creative darkroom work, this book takes b&w to the next level! $29.95 list, 8½x11, 128p, order no. 1687.

Photographing Your Artwork

Russell Hart

A step-by-step guide for taking high-quality slides of artwork for submission to galleries, magazines, grant committees, etc. Learn the best photographic techniques to make your artwork (be it 2-D or 3-D) look its very best! $29.95 list, 8½x11, 128p, 80 b&w photos, order no. 1688.

Posing and Lighting Techniques for Studio Photographers

J.J. Allen

Master the skills you need to create beautiful lighting for portraits of any subject. Posing techniques for flattering, classic images help turn every portrait into a work of art. $29.95 list, 8½x11, 120p, 125 full-color photos, order no. 1697.

Corrective Lighting and Posing Techniques for Portrait Photographers

Jeff Smith

Learn to make every client look his or her best by using lighting and posing to conceal real or imagined flaws—from baldness, to acne, to figure flaws. $29.95 list, 8½x11, 120p, full color, 150 photos, order no. 1711.

Professional Secrets of Natural Light Portrait Photography

Douglas Allen Box

Learn to utilize natural light to create inexpensive and hassle-free portraiture. Beautifully illustrated with detailed instructions on equipment, setting selection and posing. $29.95 list, 8½x11, 128p, 80 full-color photos, order no. 1706.

Portrait Photographer's Handbook

Bill Hurter

Bill Hurter has compiled a step-by-step guide to portraiture that easily leads the reader through all phases of portrait photography. This book will be an asset to experienced photographers and beginners alike. $29.95 list, 8½x11, 128p, full color, 60 photos, order no. 1708.

Professional Marketing & Selling Techniques for Wedding Photographers

Jeff Hawkins and Kathleen Hawkins

Learn the business of successful wedding photography. Includes consultations, direct mail, print advertising, internet marketing and much more. $29.95 list, 8½x11, 128p, 80 photos, order no. 1712.

Photographers and Their Studios

Helen T. Boursier

Tour the studios of working professionals, and learn their creative solutions for common problems, as well as how they optimized their studios for maximum sales. $29.95 list, 8½x11, 128p, 100 photos, order no. 1713.

Advanced Infrared Photography Handbook

Laurie White Hayball

Building on the techniques covered in her *Infrared Photography Handbook*, Laurie White Hayball presents advanced techniques for harnessing the beauty of infrared light on film. $29.95 list, 8½x11, 128p, 100 photos, order no. 1715.

Traditional Photographic Effects with Adobe Photoshop

Michelle Perkins and Paul Grant

Use Photoshop to enhance your photos with handcoloring, vignettes, soft focus and much more. Every technique contains step-by-step instructions for easy learning. $29.95 list, 8½x11, 128p, 150 photos, order no. 1721.

Master Posing Guide for Portrait Photographers

J. D. Wacker

Learn the techniques you need to pose single portrait subjects, couples and groups for studio or location portraits. Includes techniques for photographing weddings, teams, children, special events and much more. $29.95 list, 8½x11, 128p, 80 photos, order no. 1722.

Photographic Lenses

PHOTOGRAPHER'S GUIDE TO CHARACTERISTICS, QUALITY, USE AND DESIGN

Ernst Wildi

Gain a complete understanding of the lenses through which all photographs are made—both on film and in digital photography. $29.95 list, 8½x11, 128p, 70 photos, order no. 1723.

The Art of Color Infrared Photography

Steven H. Begleiter

Color infrared photography will open the doors to an entirely new and exciting photographic world. This exhaustive book shows readers how to previsualize the scene and get the results they want. $29.95 list, 8½x11, 128p, 80 full-color photos, order no. 1728.

Photographer's Filter Handbook

Stan Sholik and Ron Eggers

Take control of your photography with the tips offered in this book! This comprehensive volume teaches readers how to color-balance images, correct contrast problems, create special effects and more. $29.95 list, 8½x11, 128p, 100 full-color photos, order no. 1731.

Photo Salvage with Adobe® Photoshop®

Jack and Sue Drafahl

This indispensible book will teach you how to digitally restore faded images, correct exposure and color balance problems and processing errors, eliminate scratches and much, much more. $29.95 list, 8½x11, 128p, 200 full-color photos, order no. 1751.

Beginner's Guide to Adobe® Photoshop®

Michelle Perkins

Learn the skills you need to effectively make your images look their best, create original artwork or add unique effects to almost image. All topics are presented in short, easy-to-digest sections that will boost confidence and ensure outstanding images. $29.95 list, 8½x11, 128p, 150 full-color photos, order no. 1732.

The Art of Black & White Portrait Photography

Oscar Lozoya, with text by Peter Skinner

Learn how master photographer Oscar Lozoya uses unique sets and engaging poses to create black & white portraits that are infused with drama. Includes lighting strategies, special shooting techniques and more. $29.95 list, 8½x11, 128p, 100 full-color photos, order no. 1746.

Lighting Techniques for High Key Portrait Photography

Norman Phillips

From studio to location shots, this book shows readers how to meet the challenges of high key portrait photography to produce images their clients will adore. $29.95 list, 8½x11, 128p, 100 full-color photos, order no. 1736.

Photographer's Lighting Handbook

Lou Jacobs Jr.

Think you need a room full of expensive lighting equipment to get great shots? Think again. This book explains how light affects every subject you shoot and how, with a few simple techniques, you can produce the images you desire. $29.95 list, 8½x11, 128p, 130 full-color photos, order no. 1737.

Lighting and Exposure Techniques for Outdoor and Location Portrait Photography

J. J. Allen

The changing light and complex settings of outdoor and location shoots can be quite challenging. With the techniques found in this book, you'll learn to counterbalance these challenges with techniques that help you achieve great images every time. $29.95 list, 8½x11, 128p, 150 full-color photos, order no. 1741.